Christiane Weidemann

Leonardo da Vinci

Prestel

Munich · Berlin · London · New York

Contents

Context

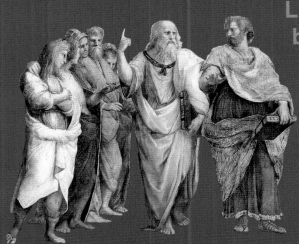

"There is no such thing as patriotic art or patriotic science. Like all high blessings, both belong to the world at large, and can be promoted only by the universal, unimpeded inter- action of all those alive at a given time, ever mindful of what is left and familiar to us of the past."

J. W. von Goethe

The Renaissance — Cultural Revival in Italy

"Nothing animates the spirits of man more or lessens the apparent toils of study than the honour and benefit to be gained from art and skill after hard work."

Giorgio Vasari

Cover of Vasari's *Lives of the Painters*, with a portrait of Leonardo.

The cultural transformation of Europe from the 14th to the 16th centuries ...

... is known as the Renaissance. As a term for a style, it was first used by painter and artist-biographer Giorgio Vasari. What he meant by *rinascita* ("re-birth") was the re-awakening of classical antiquity and the revival of the arts. Thus in 1550, Vasari established an art-historical model that first established a sequence of antiquity, the Middle Ages and his own day (the modern era) as separate periods following one after the other. The Renaissance is seen as a time of profound changes, of great ideas and of optimistic expectations of the future.

During the Renaissance ...

-→ classical philosophers were studied again

-→ all Plato's writings were translated into Latin

-→ a God-centred universe gave way to one based on man.

6

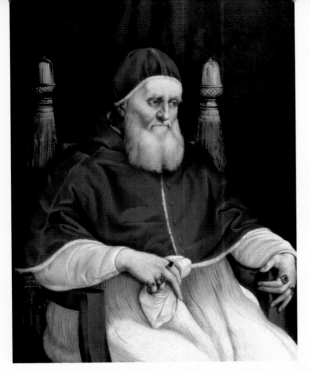

The artistic centres of Italy

Florence became known as the "cradle of the Renaissance." The economic and culture upswing of the 14th and 15th centuries created a climate in which ideas, scholarship, literature, painting, sculpture and architecture flourished. Pioneers of a radical revival of the arts were the wealthy Medici family, the pre-eminent patrons of the period. In the 16th century, Rome became the Europe's art school. Pope Julius II (left) patronized some of the most gifted artists of the young generation such as Bramante, Raphael and Michelangelo.

The Medici

In Renaissance Florence, the Medici were among the most influential families. They established a modern banking system, thereby laying the foundations not only of their wealth and reputation but also of their political power and authority. As important cultural patrons, they were the friends, clients and collectors of artists such as Donatello, Botticelli, Michelangelo and Leonardo da Vinci. One of the most brilliant of the Medici was Lorenzo the Magnificent (right), who lived from 1449 to 1492.

The great chronicler of Florentine art

The Lives of the Most Excellent Painters, Sculptors and Architects (*Le Vite de' più eccellenti pittori, scultori, e architettori*) by Giorgio Vasari (1511–1574) is still a key work of reference for our knowledge of the Italian Renaissance. First published in 1550, the *Lives* contain descriptions of numerous works of art now lost. For Vasari, Florentine art achieved its highest expression in the works of Leonardo, Raphael and Michelangelo.

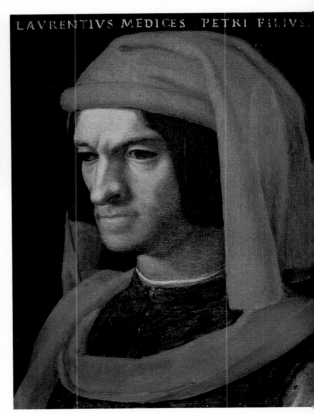

LAVRENTIVS MEDICES PETRI FILIVS

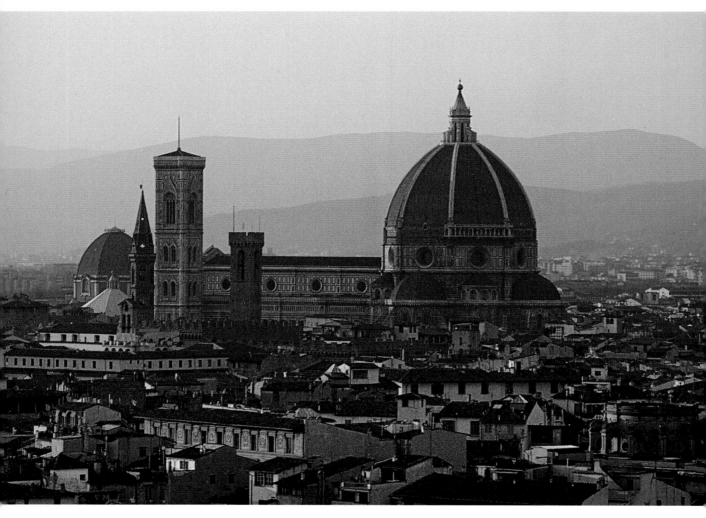

The cathedral Santa Maria del Fiore in Florence is a master work of the early Renaissance. With his dome, Brunelleschi had "challenged heaven itself," as Vasari put it. The contract for putting the globe with the crucifix on top was awarded in 1448 to Verrocchio's workshop, where Leonardo worked as an assistant.

Sculptor, painter and poet, Michelangelo Buonarroti was one of the outstanding representatives of the Renaissance.

A New Age of the Arts

Leonardo da Vinci lived in one of the most turbulent periods in human history. The Renaissance marked the transition from the "dark" Middle Ages, centred on God and the next world, authority and tradition, to the modern era with an empirical outlook focused on this world, reason and experience.

Starting from an Italian base but spreading over the whole of Europe, painting, music, sculpture, architecture, literature and philosophy, the sciences and history writing all set themselves new intellectual objectives. They generated an impressive breadth of new insights, forms of expression and ways of thinking. Art discovered individuality in portraiture, the human physique in the nude and, with the help of perspective, the laws governing the representation of spatial depth. The driving force behind these comprehensive innovations was the rediscovery of classical antiquity, bound up with a denial of the immediate past, the Middle Ages.

"Watch fish swimming in the water, and you will understand the flight of birds in the air."

Leonardo da Vinci

Leon Battista Alberti was of the leading writers on art theory in the Renaissance, setting out the basic concepts of perspective in his treatises on painting.

Italian cities such as Venice, Florence, Naples, Milan and Rome vied for cultural supremacy. In these cities there was a steady demand for painting, sculpture and architecture, and rewards were commensurate. Humanist popes and Florentine merchants and rulers acquired both reputations and legitimation through a liberal investment in the arts. Artists were also in demand at the courts of generous princes such as Federico da Montefeltro and Ludovico Sforza, the dukes of Urbino and Milan respectively, who could guarantee them an income.

Whereas in the Middle Ages painters and sculptors had been considered artisans, organizing themselves into trade guilds like stonemasons or bakers, during the Renaissance they became more independent and claimed a higher professional status, the guilds steadily losing ground among producers of art. Anxious to improve their social standing as well, artists sought to demonstrate the intellectual nature of their activity. A theoretical background was therefore an important means of demarcating artists from mere craftsmen. In this connection, humanist Leon Battista Alberti was of particular importance, for he was the founder of art theory in the mid-15th century. The effect of his first treatise on painting (*De Pictura*, 1434) on his contemporaries cannot be overestimated, and there followed similar treatises on architecture and sculpture.

Alberti is often described as the first Renaissance man. He was active not just as a writer on art and author, but also as an architect, musician, stage designer and urban planner. The breath of Alberti's interests acted as a model for Leonardo, and his ideas often crop up in the latter's manuscripts.

Thus a modern artistic self-awareness developed, and an artist's personal style became a hallmark of quality that clients looked for in his works, particularly from the 1520s. Vasari's collection of biographies and his concept

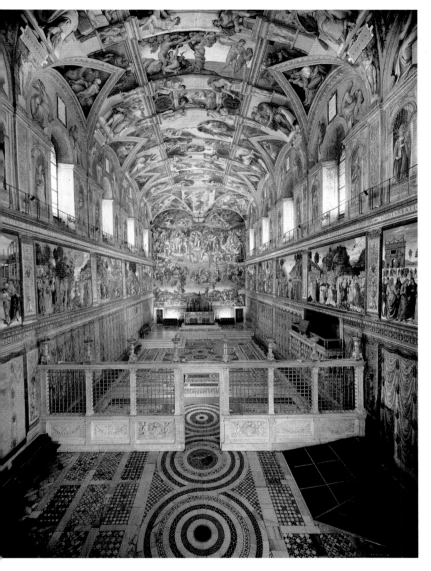

View of the Sistine Chapel
with Michelangelo's famous
frescoes on the ceiling and
far wall.

and personal inventiveness set up a creative tension within the canons of Renaissance art that was not entirely compatible with the requirement for compositional clarity of perspective, lifelikeness and the imitation of classical models.

The key ideas of the Renaissance

In his books, Alberti summed up the new knowledge and skills artists had acquired through trial and error. He was the first to formulate a theory of central perspective based on exact geometrical design, by means of which representations of real and imagined scenes alike could acquire a greater degree of realism. This new technique of spatial representation was first applied by architect and sculptor Brunelleschi and the painter Masaccio, two of the most important personalities in the brilliant revival of the arts.

of the "divine artist" highlighted the newfound status of painters, architects and sculptors of the day. From the mid-16th century, the fame of a work was primarily and ultimately bound up with the personality of the artist, so that patrons increasingly found themselves overshadowed. In time, the new demands for originality

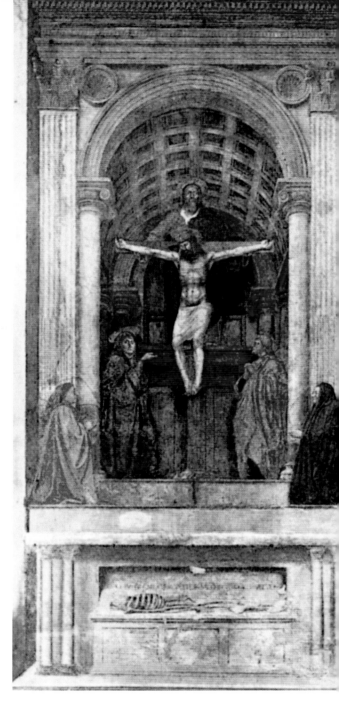

Masaccio's *Trinity* fresco in the church of Santa Maria Novella in Florence is considered a textbook early example of the use of central perspective.

The aims of the early Renaissance were to imitate nature and render the real world as accurately as possible. By the 16th century, this was combined with the ambition of representing an "inner idea" in the work of art. The works of Leonardo likewise reveal the artist's efforts to explore the laws of nature. Studies of proportions like his famous drawing based on Vitruvius (p. 72), the result of his close study of the human body, had a long-term effect on art and architectural theory. Nature studies served as a basis for an idealistic artistic design. The best works of Italian Renaissance art are notable for their perfection and balance, and reflect the formal ideals of this brilliant cultural period. They reveal nothing of the internal conflicts of the age, war, hardship and violence and the often harsh living conditions. It was left to the various styles of Mannerism to counter the dogma of harmony, and to reveal a disconcerting and formally arbitrary view of the world.

Painter and Dominican monk
Fra Angelico painted altarpieces
that manifest deep piety. The
predella of the *Annunciation*
altarpiece shows scenes from
the life of the Virgin.

Art outside Italy

The most notable representative of Netherlandish painting in matching the quality of Italian art was Jan van Eyck, who, like Brunelleschi, Fra Angelico and Masaccio, counts as one of the founders of the Renaissance. He highlighted early on the European dimension of this period of art. In Germany, following a formative trip to Venice, Albrecht Dürer followed the model of Italian artists.

In France, Francis I was particularly anxious to foster the development of Renaissance culture. Leonardo was the first of a whole series of Italian artists who came to his court. Thanks to the French king's comprehensive reform programme, Italy's neighbour ultimately took over the leading position in European culture.

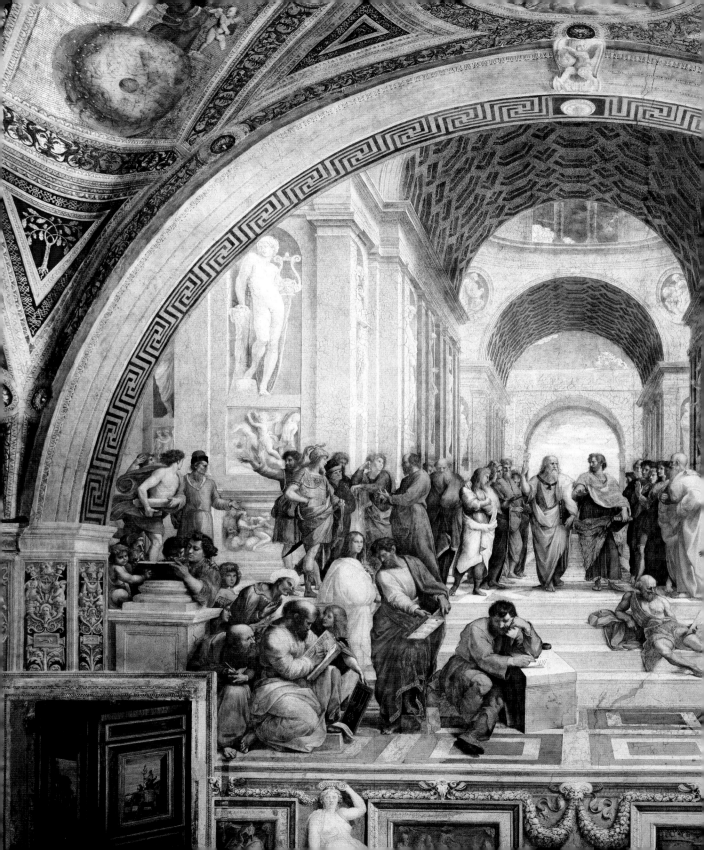

Extolling classical thought At the behest of Pope
Julius II, Raphael worked from 1510 to 1511 on frescoes for
the Stanza della Segnatura in the Vatican. This famous scene,
The School of Athens, shows a gathering of celebrated thinkers of
antiquity, with Aristotle (right) and Plato in the centre background.

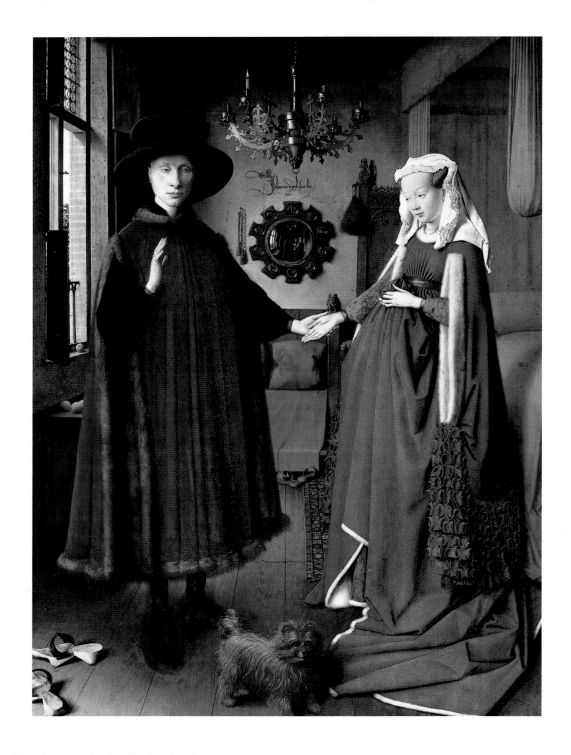

The Renaissance in the Netherlands Jan van Eyck was one of the founders and chief exponents of naturalism in northern European painting. Among the Flemish artist's principal works is this double portrait of Giovanni Arnolfini and his bride Giovanna Cenami, dating from 1434. It is also known as the *Arnolfini Wedding*.

BUSINESS REPLY MAIL

FIRST-CLASS MAIL PERMIT NO. 54 LEHIGH VALLEY, PA

POSTAGE WILL BE PAID BY ADDRESSEE

Bicycling.

PO BOX 26299
LEHIGH VALLEY PA 18003-9911

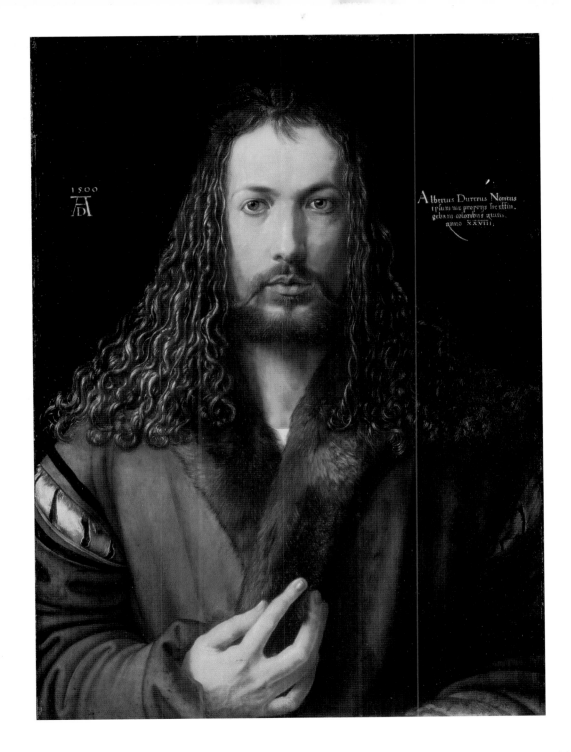

The North discovers the South Albrecht Dürer's self-portrait *(Self-Portrait in a Fur Coat)* was painted following a formative visit to Italy. The self-assured artist's Christ-like pose proclaims the creative privilege of the artist.

Fame

"He suddenly broke away from traditional 15th-century painting. Without error, without weak-nesses, without exaggerations, he arrived, as if at a single bound, at this rational, scholarly naturalism that is as far from slavish imitation as it is from an empty, illusory ideal."

Eugène Delacroix on Leonardo da Vinci, 1860

Artist, Scientist, Magician — Images of a Genius

"Perhaps there is no other example anywhere in the world of such a universal, inventive spirit ..."
Hippolyte Taine on Leonardo da Vinci, 1866

The Leonardo phenomenon

"To try to write a book about Leonardo without once using word 'genius' would be a feat worthy of the French author Georges Perec, who contrived to write a book without using the letter *e*." One can hardly put Leonardo's fame into words more succinctly than Charles Nicholl. Leonardo is considered the universal genius of the Renaissance, with a mysterious greatness as an artist, scientist and philosopher.

"It could be true that one has to be more than the work in order to create it, and that greatness has its origin in something greater. Certain phenomena at least, such as Leonardo, Goethe and even Tolstoy, suggest this assumption."

Thomas Mann, 1928

"That evening I went for a walk with compatriot, and we argued about ou preference for Michel Angelo or Raphael I favoured the former, he the latter and we finally agreed on our join acclamation of Leonardo da Vinci.
J. W. von Goethe, 178

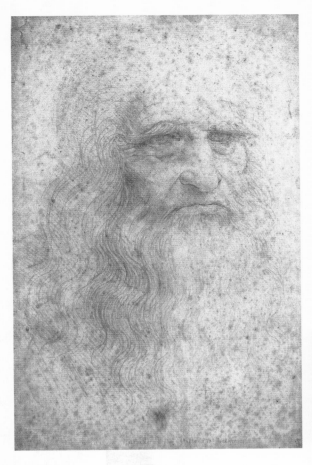

Character head

The famous *Turin Self-Portrait* has been a major factor in fashioning the image of Leonardo as an artistic genius and natural philosopher. It shows an elderly man with long hair, beard and bushy eyebrows, "a greybeard beyond space and time who has such profound knowledge that it can no longer be told" (Daniel Arasse). But was the portrait really by him? In recent times, the authenticity of the portrait has been challenged because of contradictions in the chronology of its genesis. In short, we can no longer say with certainty that we know what Leonardo looked like.

> "There then arise those marvellously incomprehensible and inexplicable beings, those human enigmas predestined to conquer and seduce, the finest example of which ... among artists, is perhaps Leonardo da Vinci."
>
> **Friedrich Nietzsche, 1886**

Uomo universale

Leonardo da Vinci is considered a textbook example of the *uomo universale*, the "universal man" of many talents and skills — an ideal that developed in the Renaissance. Lorenzo Ghiberti, one of the pioneering artists of the early Renaissance, wrote in his *Commentarii* (published in 1540, but completed c. 1447): "The sculptor and the painter must be very experienced in all the liberal arts, since these involve grammar, geometry, philosophy, medicine, astronomy, perspective, history, anatomy, the theory of drawing, arithmetic ..." Leonardo's interests eventually spread into all these disciplines.

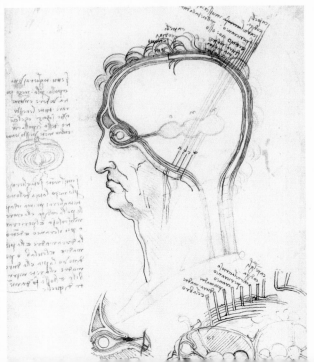

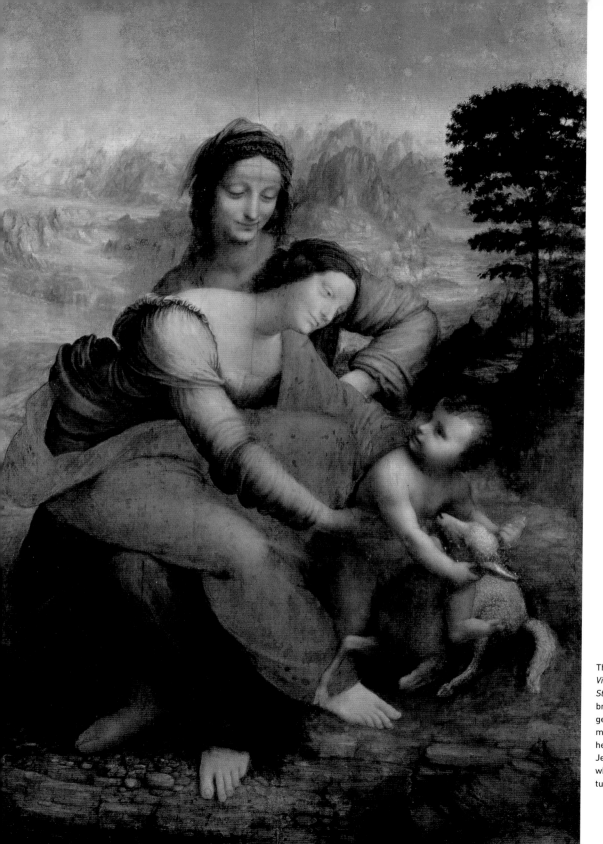

The famous painting *Virgin and Child with St Anne* in the Louvre brings together three generations — Mary's mother Anne, Mary herself and the Child Jesus — a subject to which Leonardo returned several times.

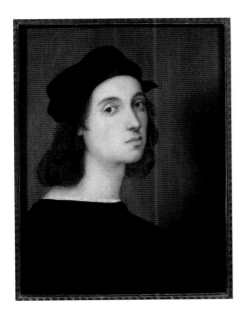

Raphael, whose father was among the first to recognize Leonardo's talent, was one of the most outstanding artists of the Renaissance. An early self-portrait by Raphael dating from c. 1509.

The Invention of a Genius

Our present-day notions of Leonardo go back to the biographies and writings of the 15th and 16th centuries. Based more on rumour than on reliable knowledge, they sketched an impressive image of an incomparable genius that survives to this day in legend and romantic myths.

A whole series of historical sources document what his contemporaries thought. Giovanni Santi, father of Raphael and a painter in Urbino, was one of the first to demonstrate great admiration for Leonardo. In a rhyming chronicle found in his estate on his death in 1484, he rated Leonardo as one of the leading painters of his day. A sonnet written by Milanese poet Bernardo Bellincioni in the following decade called him one of the "four divine stars" at the court of Ludovico Sforza. According to Ugolino Verino in his historical chronicle of the city of Florence, Leonardo surpassed all other artists. And finally, mathematician Luca Pacioli describes him in *Divina Proportione* (Divine Proportion, 1509), his great work on the golden mean in art, with

> **"Even if you have only briefly glimpsed it, you can never forget it."**
>
> **George Sand on the *Mona Lisa***

The fruitful collaboration with Leonardo's friend Luca Pacioli, a Franciscan monk and mathematics professor (seen right in a painting by Jacobo de' Barbari) led to the production of the book *Divina Proportione* (Divine Proportion), a major work on the golden mean containing around 60 illustrations by Leonardo.

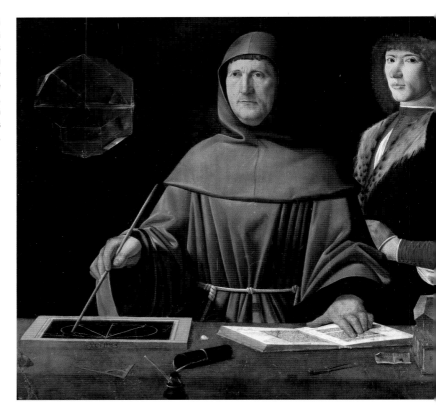

illustrations by Leonardo, as "that most formidable painter, expert on perspective, architect and musician Leonardo of Florence, blessed with a capability for everything."

It was above all Vasari, in his *Lives of the Painters*, who set his indelible mark on our image of Leonardo as an exceptional personality. Vasari was still a child when Leonardo died. Writing his biography around 30 years after Leonardo's death, he attributed to his subject the role of forerunner of the *bella maniera* (the "beautiful style" that would characterize Mannerism), thereby immediately identifying him as a model for later Renaissance artists such as Raphael. The idea of the "divine artist" crops up here, just like other qualities described

as characteristic — Leonardo's penchant for perfectionism, his extraordinary inventiveness, and the universality of his interests. Like other authors before him, Vasari praised Leonardo's courtly nature, his physical beauty and his "divine charm." He depicts him as "tall and of regular stature, perfect beauty of countenance and unusual physical strength." The culmination of his life of the artists is a description of Leonardo's death in the arms of the French king, Francis I — probably legend. Nonetheless, the story placed a crown of nobility on the artist.

Arduous beginnings

Yet it was not at all as smooth going for Leonardo at the start of his artistic career as one might presuppose from

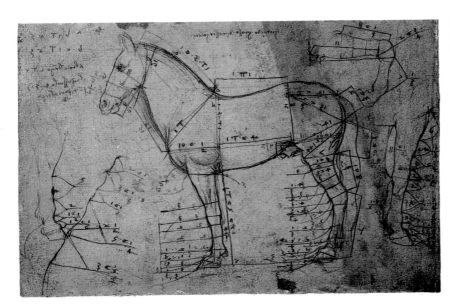

Leonardo's studies of proportions are considered one of the major achievements of the Renaissance.

his later fame. His early days in Florence bear witness to the difficulties he had in establishing himself. After training in Verrocchio's studio, he initially worked on small-format devotional pictures and portraits, which generated little income. Only with the commissions for altarpieces for the chapel of San Bernardo in the Palazzo Vecchio and later for the monastic church of San Donato di Scopeto did he receive more substantial commissions, and these he owed to his father's professional contacts. It seems that in 1481 important patrons did not rank him with fashionable Tuscan painters such as Botticelli, Ghirlandaio, Perugino and Signorelli. These artists were invited to do frescoes for the walls of the Sistine Chapel in Rome, and he wasn't. To some extent, it was his own fault. He had a difficult relationship with patrons because he did not meet his deadlines nor the terms of his contracts. More than once he failed to follow instructions or left works unfinished. Only after he was taken on as Sforza court artist in Milan, and especially with the tasks he undertook for the French king, Francis I, did his financial circumstances improve. Even then, Leonardo's in-

come was far from commensurate with his later reputation, particularly when compared with the fortune that Michelangelo managed to assemble.

Admiration in France

The French had a high opinion of Leonardo from the first, as a letter from the French governor of Milan, Charles d'Amboise, dated 1506 bears out: "We loved him before we met him personally, but now we have been in his company and can speak about his diverse talents from personal experience, we see that his name, if already famous for the paintings, has not been sufficiently praised for the many other gifts that he possesses and which are of extraordinary power." King Louis XII was so impressed by Leonardo's *Last Supper* that he wanted to take the work back home with him, despite the difficulties of moving a fresco. The sculptor Benvenuto Cellini records the words of King Francis I, saying he was "passionately infatuated with his [Leonardo's] great talents. ... He could never believe that any other person was ever born who knew so much as Leonardo, not only about sculpture, painting and

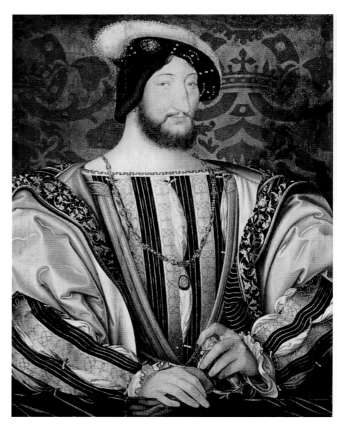

French king Francis I, Leonardo's last patron, in a portrait by Jean Clouet.

architecture, but also inasmuch as he was a great philosopher."

Myth and renown

Leonardo's artistic reputation was principally established by his painting of the *Last Supper* in the 1490s. Shortly afterwards, he was commissioned to create an altarpiece for the monastery of Santissima Annunziata, one of the richest churches in Florence. Vasari commented that "not only all artists but anyone who saw it felt compelled to admire it, and for two days men and women, young and old, were seen making the pilgrimage to the room where the miraculous painting by Leonardo was exhibited, as if to a brilliant festivity." The spread of his fame is also borne out by his name being put forward in 1503 to execute the im-

portant fresco the *Battle of Anghiari* in the Palazzo Vecchio in Florence.

Leonardo's fame was principally based on his paintings. In the eyes of many of his contemporary biographers, his scientific studies and experiments were peripheral, time-consuming ventures that kept him from art. Vasari mentions a number of eyebrow-raising episodes in connection with Leonardo's "strange" urge to experiment: "He often had the guts of a castrated ram cleaned so thoroughly it could be held in the hollow of the hand. He carried it into a large room, took a couple of smithy bellows into a neighbouring room, attached the guts to them and pumped them up until they filled the whole room and everybody was pushed into the corner. ... He did all kinds of tomfoolery like that."

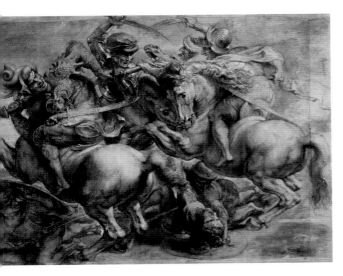

Rivalry between two great artists of the Renaissance: *Leonardo's Battle of Anghiari* (left, in a copy by Rubens) and Michelangelo's *Battle of Cascina* (below, in a copy by Aristotile da Sangallo) at the Palazzo Vecchio in Florence.

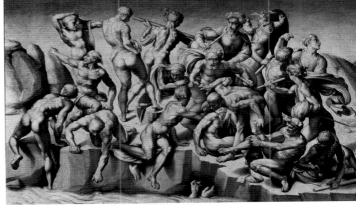

The image of Leonardo as a great theoretician of classical painting was established no later than the mid-17th century by the publication of his *Trattato della Pittura* (Treatise on Painting) in French and Italian. The treatise constituted an anthology of his writings on paintings compiled after his death by his pupil and executor Francesco Melzi. With the great variety of studies he did of the diversity of human character and expression being widely reproduced, he also became famous as a creator of "grotesque heads" or caricatures (p. 67).

It was particularly in the 19th century, with its obsession for the Italian Renaissance, that Leonardo was adopted as a "modern" artistic personality and inquiring genius. Although at the outset Michelangelo, Titian and Raphael had noticeably higher reputations, ultimately it was Leonardo who came to be seen as one of the most famous representatives of the period. The gradual publication of his manuscripts from the 1880s on brought to light his achievements in many other disciplines — anatomy, cartography, mechanics, optics, botany, geology, astronomy and acoustics. But instead of being valued for their specific content, his notes — which are difficult to decipher, unsystematic and fragmentary — mainly confirmed the myth of the inspired genius far ahead of his time. Only the systematic study of his estate since the end of the 20th century has revealed the scope and brilliance of his thinking. At the same time, gaps — for example in his mathematical knowledge — have come to light now that the history of art and science, and also the consideration of contemporary treatises and writings, have been properly taken into account.

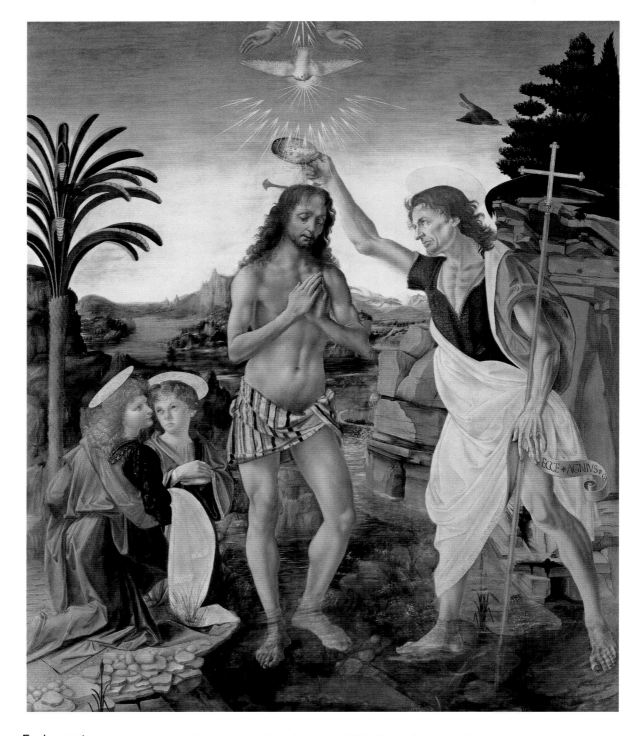

Early mastery Commissioned c. 1473, the *Baptism of Christ* (now in the Uffizi in Florence) was created by several members of Verrocchio's workshop. The celebrated kneeling angel on the far left, and part of the landscape background, came from the hand of the young Leonardo.

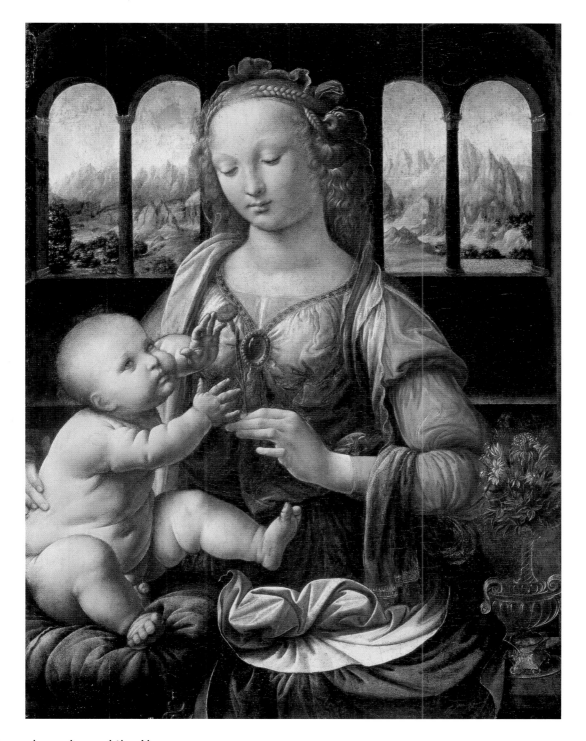

A new home beyond the Alps The *Madonna with the Carnation*, also known as the *Virgin and Child*, is one of Leonardo's early works. Somehow it ended up in Bavaria, and in 1889 was bought at auction by Josef Haug for 22 marks and sold on to the Alte Pinakothek in Munich the same year.

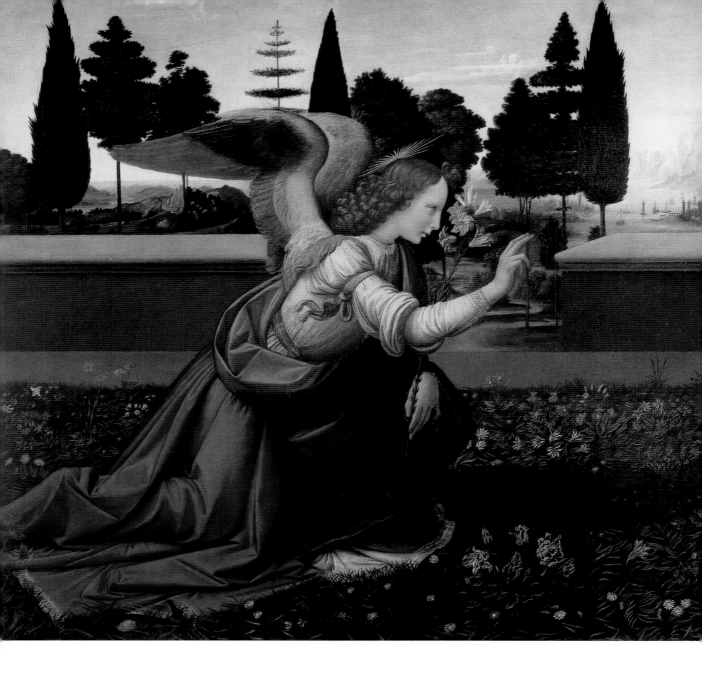

Working with others Until this panel painting of the *Annunciation* came into the Uffizi collection in 1867, it was taken to be a work by Ghirlandaio. These days, it is considered a joint effort by Verrocchio's workshop, with the hands and face of the angel and robe of the Virgin supposedly by Leonardo.

Far from devaluing him, the comparison we now get with his contemporaries brings out his particular originality all the more forcefully.

The *Mona Lisa* craze

Leonardo's incomparable fame is particularly evident in the "career" of the *Mona Lisa*, which has become a global art icon and the most famous picture in the Western world (p. 36).

Even contemporaries saw the portrait as the consummate expression of painterly skill. Vasari praises the perfect, life-like execution of every details and called the painting the very model of art imitating nature. "We may say that this picture was executed in a way which made every first-rate artist and anyone who saw it shake in his boots. ... Such a sweet smile hovers ... on this face that it seems to stem more from heavenly than human hand."

Nor are parachutes and submarines, inventions commonly attributed to Leonardo, exclusively his creations, but developments or reformulations of ideas already suggested. By putting his supposedly unlimited aptitudes into a clearer perspective, and by challenging a concept of genius bordering on deification, our present view of Leonardo has become more "human."

Printed edition of Leonardo's posthumously compiled work *Trattato della Pittura* (Treatise on Painting), this edition dated 1651.

Yet the portrait owes a great deal of its popularity to the fantasies of Romantic writers of the 19th century, who admired it as a "magical work" and read mystery into it, making the *Mona Lisa* a symbol of dangerous female beauty. This reputation as a *femme fatale* derived primarily from the gushing rhetoric of poet, novelist and art critic Théophile Gautier: "Her expression, wise, profound, velvet and full of promise, attracts you irresistibly and poisons you, while the sensual, serpentine ... mouth mocks you with so much sweetness, charm and superiority that you feel altogether sheepish, like a schoolboy in the presence of a duchess."

Other interpretations followed and her image became "bound up with the morbid Romantic fantasy of the femme fatale" until she was "co-opted into a chorus-line of dangerous beauties" (Charles Nicholl). Initially the object of erotic fantasies, the *Mona Lisa* ultimately became a screen on to which every conceivable reading can be projected, down to attempts in recent decades to see the sitter as a prostitute or even as a disguised self-portrait by Leonardo. One interpretation suggests her smile conceals teeth made black by the use of mercury as a treatment for venereal disease.

Around a decade after Gautier, in 1869, English critic and essayist Walter Pater wrote the best-known description of the painting: "The presence that rose thus so strangely beside the waters, is expressive of what in the ways of a thousand years men had come to desire. It is a beauty ... into which the soul with all its maladies has passed! ... Like the vampire, she has been dead many times, and learned the secrets of the grave; and has been a diver in deep seas, and keeps their fallen day about her."

A spectacular art robbery

What happened on the morning of 21 August 1911 finally made the *Mona Lisa* into an international celebrity. Italian-born Vincenzo Perugia had worked for some time in the museum, and walked unchallenged from the building, having managed to hide the

painting under his working smock. The police initially suspected Pablo Picasso and even arrested the poet and art critic Guillaume Apollinaire! Perugia managed to keep the painting hidden in his flat for two years. In Paris, the theft was treated like a death in the family — people trooped to the Louvre to see the empty space where the Mona Lisa had once hung. Outside the Louvre, business in postcards and reproductions was brisk. At the end of 1913, Perugia tried to sell the picture to an antiques dealer in Florence. He was arrested the same day and sentenced to 12 months in prison. The press went overboard when Leonardo's painting turned up again "as in a miracle." After a tour through the cities of Italy, it was brought back to Paris.

The *Mona Lisa* as a cultural ambassador

The unique cultural status of the painting was finally made clear by its loan to the USA in the winter of 1962–1963, which, organized exclusively by the White House, was unparalleled in the history of exhibitions. Under the 24-hour supervision of security guards, the *Mona Lisa* travelled first class like a queen aboard the luxury liner *France*, escorted by ships from the American Navy. Shore transport in America was in a bulletproof limo followed by a row of vehicles full of security guards and policemen.

The nation's political and cultural elite gathered at the National Gallery of Art in Washington on 8 January 1963 for the opening of the exhibition. It was clear from

A postcard celebrating the return of the *Mona Lisa* to the Louvre in January 1915.

American soldiers guarding the *Mona Lisa* during the exhibition at the National Gallery in Washington in 1963.

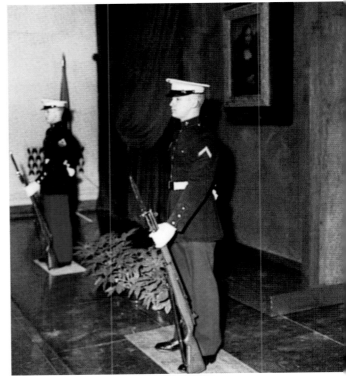

President Kennedy's opening speech that Leonardo's portrait was being celebrated not for its own sake as the greatest work of art of all time. The painting was being pressed into the service of political and ideological objectives, to consolidate Franco-American relationships and to defend the values of the Western world against Communist countries. The *Mona Lisa* itself threatened to sink from sight and lose all its identity under all this political baggage. However, the journey to America undoubtedly did its popularity a lot of good. Almost two million visitors streamed into the National Gallery and the Metropolitan Museum of Art in New York, the number of reproductions soared into the stratosphere, and the media worked hard to make the portrait better-known to those unfamiliar with it.

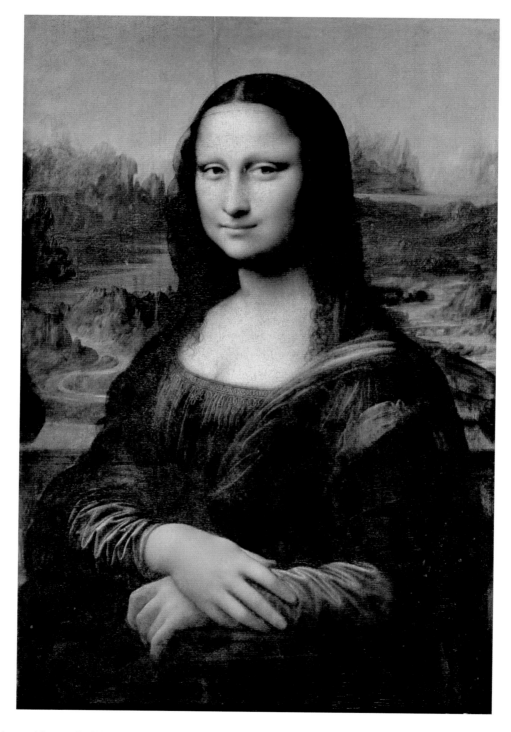

Art icon Leonardo's portrait of Lisa del Giocondo is "the most famous painting in the world," according to the subtitle of one book on the *Mona Lisa*. It has been a fascinating conundrum ever since it was painted.

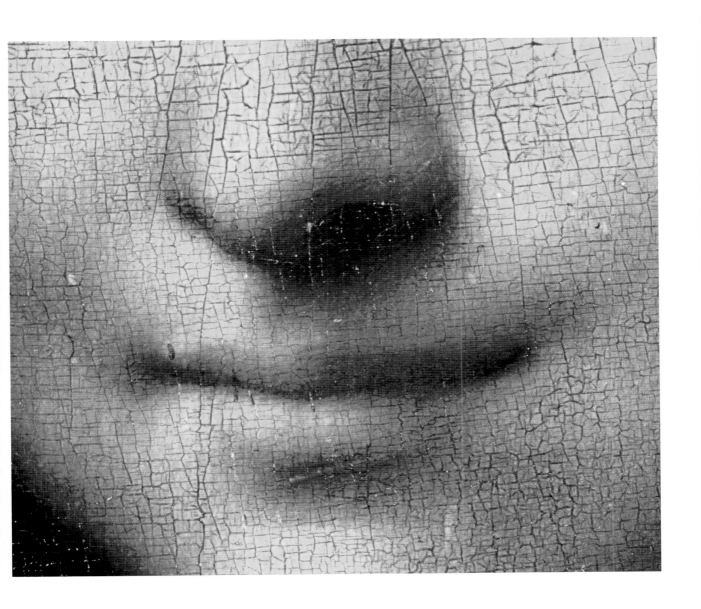

The *Mona Lisa*'s secret "While he was painting her, he got people to make music, sing and tell jokes, to keep her in a good mood," according to an anecdote by Vasari about the sitter in Leonardo's famous portrait. The reason for her perpetual smile is something that has engaged critics' and art lovers' attention time and again.

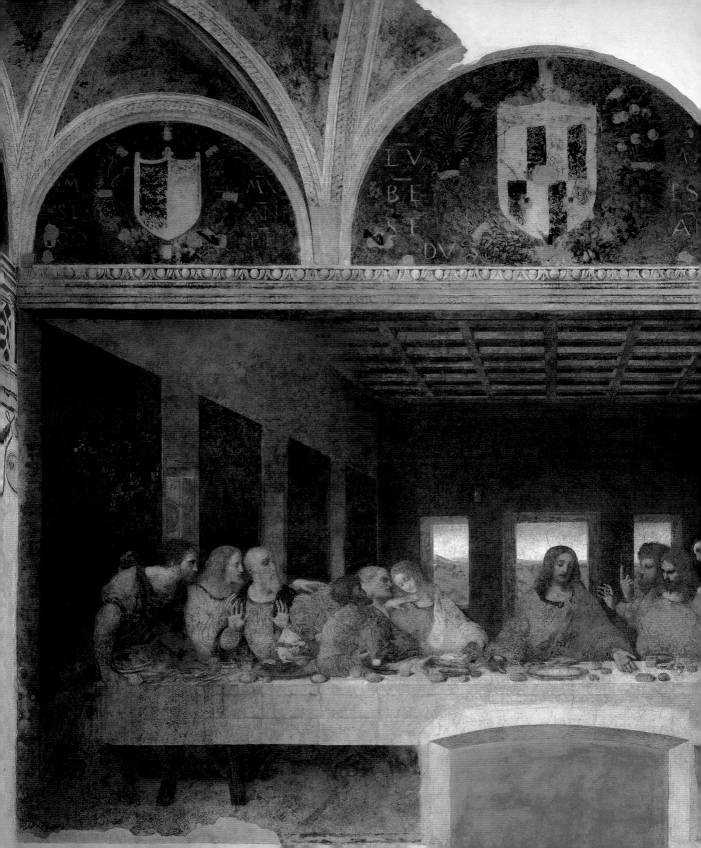

The *Last Supper* "One cannot imagine more tense attentiveness than that of the Apostles when they hear the voice of ineffable truth saying: 'One of you will betray me.' Their gestures and expressions suggest they are talking excitedly to one neighbour, then the other, with shock and astonishment. This is the miracle that our Leonardo created with his sensitive hand."

Luca Pacioli, 1498

Art

"Leonardo begins with the inside, the spiritual topography, rather than with carefully considered outlines. The painted substance is laid down as the final stage, like a breath on top of the actual, immaterial, quite indescribable version of the picture — if he gets that far and doesn't leave the picture unfinished."

Oswald Spengler, 1917

High Points of Renaissance Art

Leonardo's generally acknowledged importance for the history of art is all the more remarkable given the small number of works he finished. Incorporating the ideas and ideals of the Italian Renaissance, his few paintings represent its supreme flowering.

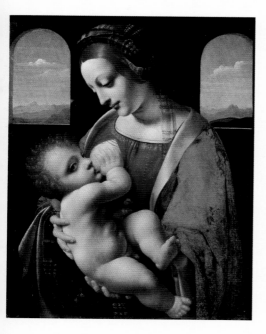

The *Litta Madonna* in the Hermitage in St Petersburg is listed as a work by Leonardo, but this attribution is contested.

Leonardo has created ...

... very few works of art compared to other famous artists of the Renaissance. Only the portraits of Ginevra de' Benci, Cecilia Galleriani and Lisa del Giocondo, the paintings of the *Adoration of the Magi* and *St Jerome*, the first version of the *Virgin of the Rocks*, the *Last Supper*, the *Burlington House Cartoon* and the *Virgin and Child with St Anne* are acknowledged as incontestably by his hand. A further nine works are attributed to him in most of the literature. If we add a further five paintings considered lost, Leonardo's total output consists of barely two dozen works of art.

Important artists of the early Renaissance include ...

→ **Filippo Brunelleschi** (architect and sculptor, 1377 –1446)

→ **Lorenzo Ghiberti** (sculptor, 1378–1455)

→ **Donatello** (sculptor, 1386–1466)

→ **Masaccio** (painter, 1401–1428)

→ **Andrea Mantegna** (painter, c. 1431–1506)

→ **Sandra Botticelli** (painter, c. 1445–1510)

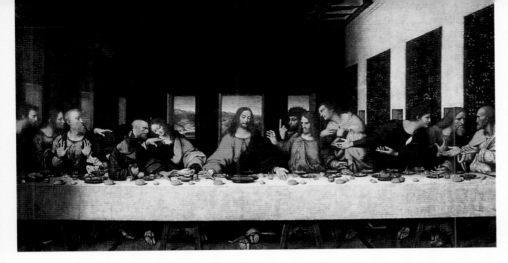

The similarity with Leonardo's painting is astonishing. This copy of the *Last Supper* was done by an unknown artist of the 16th century.

Sfumato

Derived from the Italian *sfumare* (to vanish, fade), in art *sfumato* refers to the blurring or softening of the outlines of bodies and objects so that they are no longer sharply defined — as in Leonardo's paintings, where forms are frequently characterised by soft transitions and blurred outlines. This new technique, which brought movement of figures and the fluidity of forms, became a dominant feature of his work.

Endless attempts have been made to prove that Leonardo was one of the artists who collaborated on the painting *Tobias and the Angel*, which was produced by Verrocchio's workshop.

Renaissance

In art, the Renaissance, which succeeded the International Gothic style, is generally subdivided into three periods: the Early Renaissance (c. 1420–1500) with Florence as the centre of the arts, the High Renaissance (c. 1500–1520) with Rome as its centre, and Mannerism (c. 1520–1600) as the late phase of the period throughout Europe, which in turn was succeeded by the Baroque. The Italian Renaissance set the pace in Europe for more than 200 years, and established a reputation scarcely comparable with any other period.

Chiaroscuro

Leonardo was one of the first artists to enrich European painting with chiaroscuro (contrasts of light and shadow) to achieve a sense of the three-dimensional. Using soft transitions of light and shadow, he managed not merely to depict objects more convincingly but also to convey moods and feelings. Even in the early 1470s, he rejected traditional ways of achieving relief effects by a change of colour or by using saturated local colours, experimenting instead with the addition of black and white to a colour.

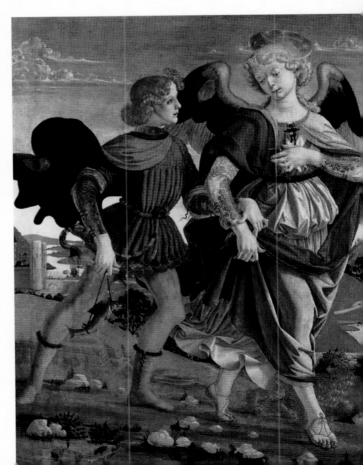

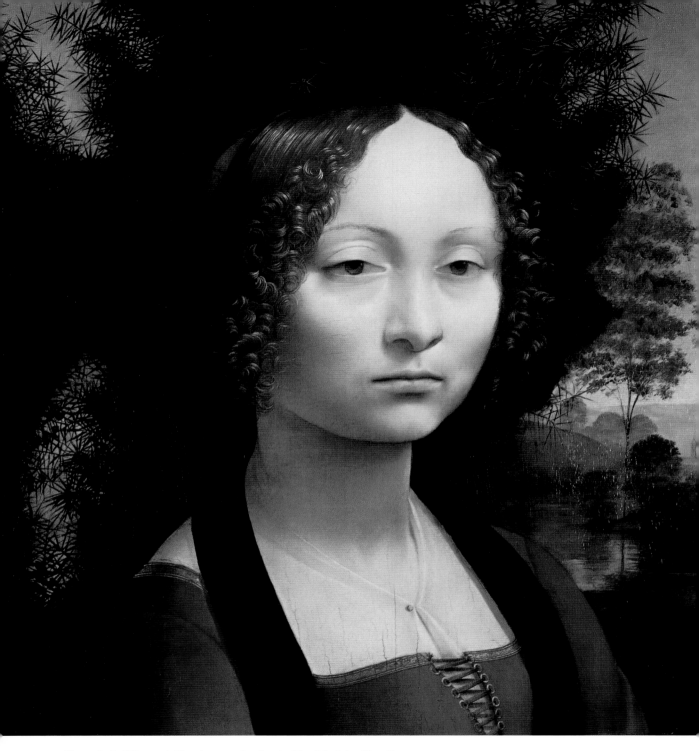

The portrait of Ginevra de' Benci represents a break with painterly tradition. The three-quarters view of the face, before reserved for male portraits, now became common in portraits of women as well.

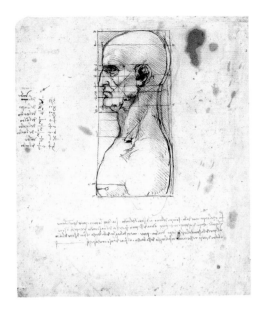

Study of a male head in profile,
with annotations of proportions.

Towards a New Art

**"Great minds often create more with less work, as they
use their minds to look for new concepts and form perfect
ideas that are expressed thereafter only with their hands,"
wrote Leonardo. His own ideas and innovative artistic tech-
niques opened people's eyes to the new things that art could
achieve.**

The starting point of Leonardo's artistic career was his com-
prehensive training in the distinguished Florentine workshop
of Andrea del Verrocchio. The training was based primarily on
drawing from models and from life. Several early studies of
clothing can be taken as examples of the exercises he did. The
training also included modelling in terracotta and clay, casting
metal, and making reliefs. Finally, there came the study of
painting. Leonardo learned about handling the basic materi-
als, the suitability of supports, preparing the ground and transferring the preliminary
drawing on to it, and the characteristics of colours. Written records bear witness to his

> **"Where nature stops
> creating her own
> images, is where man
> begins creating infinite
> pictures from natural
> things with the help
> of nature."**
>
> **Leonardo da Vinci**

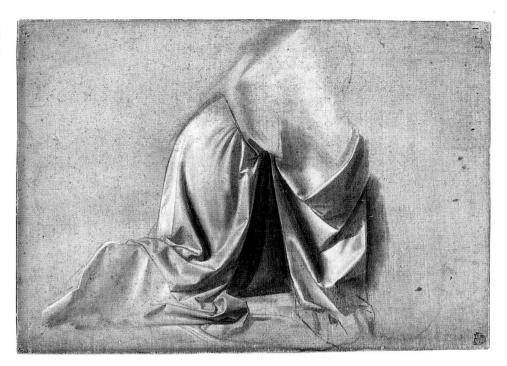

experiments to generate specific colour effects: "To make a fine red, take lake or red ochre or burnt ochre for the dark shadows, red ochre and flesh tones for the lighter ones, and for the lights flesh tones by themselves; then make a veil of the finest glaze." The training in Verrocchio's progressive workshop included a study of the achievements of Flemish painting. Leonardo practised the techniques of perspective and the use of light and shadow, and studied anatomy, optics and mathematics.

Legend has it that when he saw his pupil's first attempts at painting, Verrocchio felt himself so put in the shade that henceforth he devoted himself solely to ancillary workshop tasks. According to Vasari, Verrocchio's farewell from painting coincided with Leonardo's outstanding execution of part of the *Baptism of Christ*. The work was a joint effort by the workshop, and displays various hands. It was begun around 1470 by Verrocchio and presumably Botticelli, with Leonardo later contributing the left part of the landscape background and the kneeling angel on the far left. His angel figure stands out from the other heavenly bystanders in its delicacy and soft modelling. The differentiated representation of light and shadow is particularly clear in the folds of the garment. Whereas Verrocchio still worked with traditional tempera paints, Leonardo was already using glazing techniques in oils. He discovered what oil could do fairly early on. It was a field in which he would soon achieve mastery.

Early Madonna pictures

Leonardo's first independent works are considered to be a number of small-format devotional panels of the Madonna and Child, though the authorship is sometimes contested. Typical of his handling of the subject is the incorporation of symbolic components. In the *Madonna with the Carnation*, the carnation — the symbol of the future Passion — establishes a relationship between Mary and Jesus. The child reaches out for it, his entire attention focused on the desired object, but at the same time his reverent expression seems to express awareness of his God-given fate (p. 48).

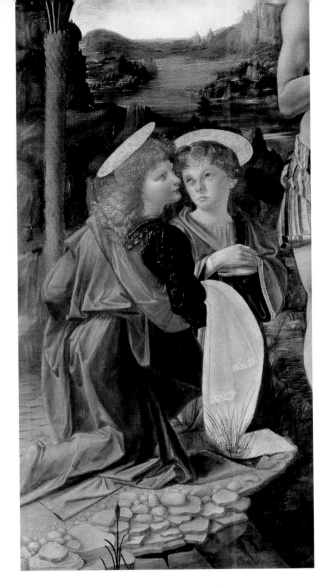

A detail from the famous joint effort from the Verrocchio workshop, the *Baptism of Christ* (p. 28). The angel on the left is thought to be by Leonardo.

Unfinished paintings

Also from Leonardo's first Florentine period is the unfinished panel *St Jerome* (p. 53). Historical sources record the 4th-century ascetic and scholar as spending five years in the desert of Chalcis as a hermit, which made him a popular subject with painters of the time. Leonardo depicts St Jerome as a penitent beating himself with a stone. The lion, a traditional attribute, witnesses the emaciated saint's self-mortification. The overtly anatomical design of the figure is remarkable for the date of the painting, and emphatically underlines the religious message.

"With his understanding of art, Leonardo embarked on many things, but never finished anything. It seemed to him that the hand had nothing to add to the completeness

Likewise in the *Benois Madonna* (p. 81), the infant Jesus sees the flower as a symbol of his future death, his mother handing it to him all unsuspecting. This later works highlights a development in comparison with the *Madonna with the Carnation* (p. 29) in showing not only Jesus but also Mary in a lively and expressive pose. Leonardo manages to show an inner relationship between mother and child by means of movements, gesture and facial expression. Some scholars also attribute the *Litta Madonna* in the Hermitage in St Petersburg and the little panel of the *Dreyfus Madonna* (p. 80) to the canon of his early Madonnas.

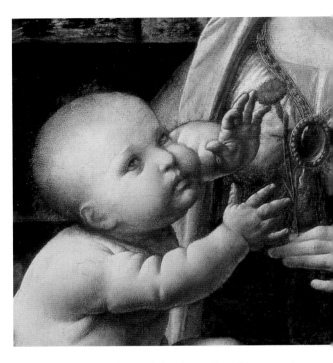

Detail from Leonardo's
Madonna with the Carnation (p. 29).

of art in the things he had already perfected in his mind, because he was wont to create a number of thoroughly subtle and marvellous difficulties conceptually which even the most adroit of hands could never have executed." This comment by Vasari and other early biographers is still the subject of research today: Why did Leonardo leave so many works unfinished? When a painting was commissioned, finishing it meant carrying it out in the way agreed with the client. Aesthetically, the meaning of the term "finished" can vary widely, and depends on the definition of beauty at any given time. Thus Leonardo's paintings, which were considered unfinished at the time, may in modern terms possibly display an inner balance that might have been ultimately destroyed if any more work had been done. The fame of works such as the unfinished altarpiece the *Adoration of the Magi* (p. 52) in the Uffizi also suggests the subordinate importance of completion. In this case, Leonardo executed only the preliminary drawing and the underpainting. Yet this altarpiece set the standard for the following generation of artists because of its innovations in

style and iconography and the dynamics of its complex composition.

His first Milanese works

In Milan, Leonardo worked with the de' Predi brothers on the decoration of a polyptych for the new chapel of the Confraternity of the Immaculate Conception in the Franciscan church of San Francesco Grande, the second largest church in the city after the cathedral. The centre panel of the altarpiece depicts an episode from the Apocryphal Gospels — the encounter between the infant Jesus and John the Baptist, which is supposed to have taken place on the Holy Family's flight to Egypt. In Leonardo, this takes place against a rocky landscape, which has resulted in the picture being called the *Virgin of the Rocks*. The centre panel exists in two similar (though not identical) versions, whose relationship remains not fully clarified to this day. The first version, which was never submitted to the confraternity, is now in the Louvre, and was mostly done by Leonardo. Only the second version, now in the National Gallery in

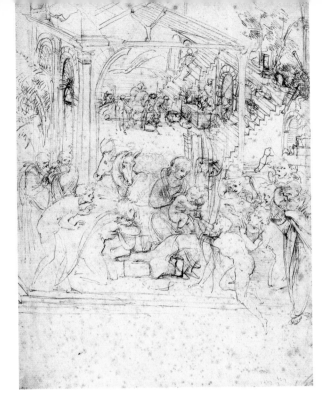

Compositional sketch for the unfinished *Adoration of the Magi* (compare p. 52).

London, was apparently accepted by the confraternity (p. 89). The existence of this second panel picture is presumably explained by a dispute with the clients over the fee, but above all by the considerable deviation in the iconography of the early version from the contracted programme. This is indicated by the addition of a number of more explicit symbols later such as the cross held by St John and the halos. Daniel Kupper regards Leonardo's *Virgin of the Rocks* as "an attempt to liberate man and nature from their religious predeterminedness and look for answers to the questions of human existence not in a Christian God but in the universal visual phenomena of divine nature."

Portrait studies

In his portraits, Leonardo made the individual the centre of interest rather than their social position. He adopted the head-and-shoulders format and the three-quarters view of the face from Flemish painting. Even the accuracy of detail, visible for example in the portrait of *Ginevra de' Benci* (p. 44) in the way the light plays on her hair, is reminiscent of the works of Netherlandish painters such as Jan van Eyck and Hans Memling.

The sitter in this portrait, Ginevra de' Benci, came from one of the richest Florentine families and had a Platonic relationship with married diplomat Bernardo Bembo, who probably commissioned the work. He described Ginevra as "the most beautiful of all women, famous for her virtue and her modesty," and that was precisely what the artist was expected to bring out in the portrait. Leonardo gives her a pale complexion and a melancholy expression, her eyes gazing into the distance. Alongside the painterly representation of female beauty revealing a virtuous soul, there is another more explicit reference to the connection between beauty and virtue on the back of the painting (p. 51). A banderole decorated with sprays of palm, laurel and juniper bears the inscription *Virtutem Forma Decorat* ("beauty distinguishes virtue"). The juniper, which also constitutes part of the background, is a symbol of the desirable characteristics of the virtuous woman's way of life, i.e. chastity and

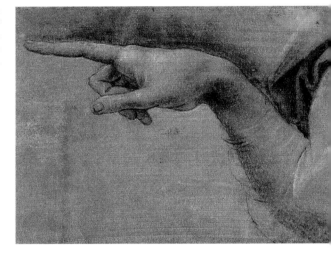

Leonardo endeavoured to express the "movements of the soul" by means of bodily movements and gestures. The index figure drawn here for the *Virgin of the Rocks* (Louvre version) recurs in other paintings as well (see p. 98).

fidelity. The Italian word for juniper is *ginepro*, and thus the plant is also an allusion to the sitter's name. *Ginevra de' Benci*, now in the National Gallery of Art in Washington, was Leonardo's first painting on a non-religious subject. It is the only major art work by the artist currently outside Europe.

Leonardo did further portraits once he was in Milan, including one of Cecilia Gallerani, mistress of the Duke of Milan, Ludovico Sforza. Today it is generally known as the *Lady with the Ermine* (p. 88). The earliest source mentioning it is a sonnet by the poet Bernardo Bellincioni:

O nature, how greatly you envy
Vinci, who painted one of your stars,
The wondrous Cecilia, whose lovely eyes
Cast even sunlight in the shade.

In shaping the figure, Leonardo put into painting what he had already formulated in his writings: head and shoulder are shown oriented in different directions so as to achieve the impression of vitality. The light falling on the shoulder also emphasises the rotation of the upper body. The same principle can be recognized in the position of the weasel, which rests itself timidly against Cecilia's left arm, while her right hand attempts to hold the animal. The spiral movement of the figures foreshadows the *figura serpentinata* ("serpentine figure"), a sinuous form which, thought to embody elegance and beauty, would later become a characteristic feature of Mannerism. The gaze of the young woman and the animal out of the picture create the impression that Leonardo was recording

Decoration on the reverse of the portrait of Ginevra de' Benci (p. 44).

a particular moment within an event. He himself described this as "the movement of the moment."

Another compositionally similar picture using the same painting technique as the portrait of Cecilia Galleriani is *Portrait of an Unknown Lady* (p. 90). This is thought to be a portrait of another of Sforza's mistresses, Lucrezia Crivelli. The jewel on her forehead — a *ferronière* — accounts for the alternative title of the picture, *La Belle Ferronière*.

The genesis of the *Mona Lisa*

The *Mona Lisa* constitutes a synthesis of Leonardo's thinking on portrait painting (p. 36). The sitter, Lisa di

Antonmaria Gherardini married Florentine silk and cloth dealer Francesco di Bartolomeo del Giocondo, who was 19 years her senior, in 1495. He commissioned the portrait in 1503 when his wife was about 24, presumably to adorn a house he had just bought. However, he never got to see the portrait, since, after four years' work, Leonardo took it with him to France, unfinished. The term Mona Lisa comes from Vasari — Monna or Mona is a contraction of Madonna, and means Mrs or Milady. In Italy the picture is known as *La Gioconda*. This is a pun, referring not just to Lisa's married name but also the adjective *giocondo* — "the jocund Mrs Giocondo."

Like all Leonardo's sitters after 1480, Lisa del Giocondo manifests the same slight rotation of the upper body. She turns to face viewers with her famous half-smile and captures them with her gaze. Regardless of the

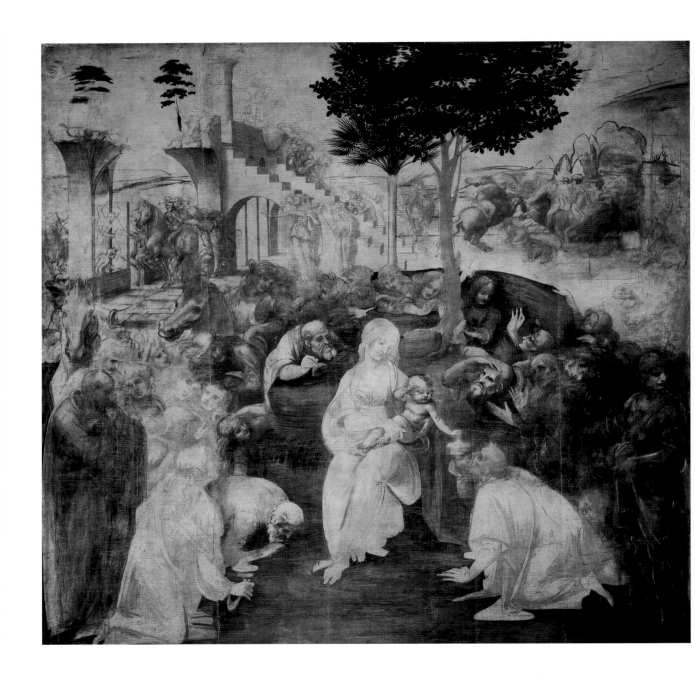

Star of Bethlehem The unfinished *Adoration of the Magi* altarpiece shows the infant Jesus in his mother's lap receiving the tributes of the Magi. They are surrounded by numerous people, some of them seeking to screen their eyes from the dazzlingly intense divine light.

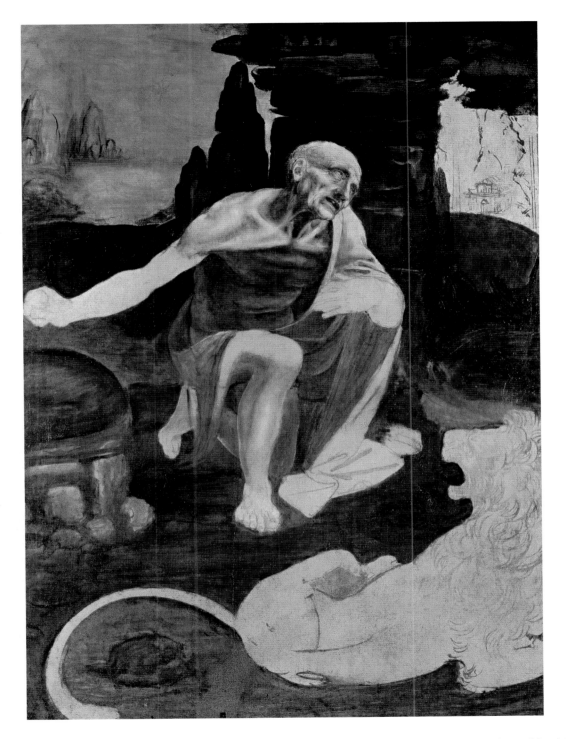

Hermit St Jerome was a favourite subject for Renaissance painters, including Masaccio, Ghirlandaio and Lorenzo Lotto. Leonardo's painting features a sketch of a church building top right, an allusion to the saint as a Father of the Church.

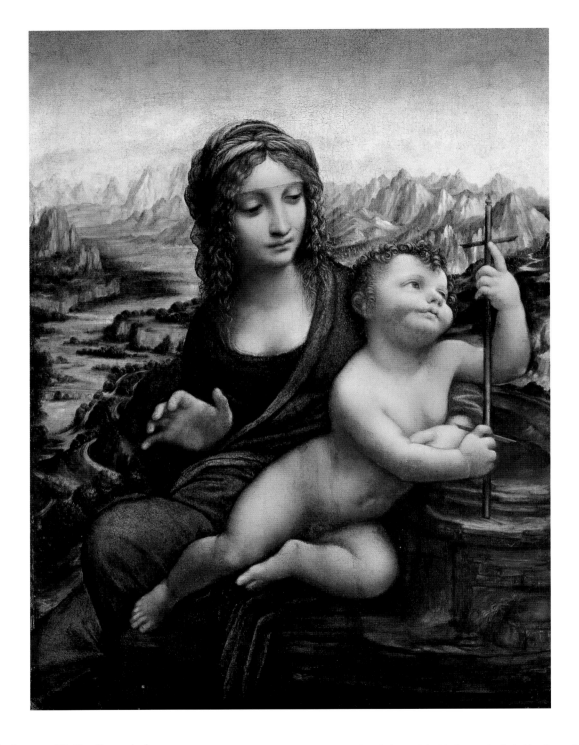

Madonna with the Yarnwinder There are various versions of this painting, copies of a lost original by Leonardo. As in his other paintings of the Virgin, in the *Redford Madonna* the child looks at the symbol of his future Passion. The copyist has transformed the yarnwinder into a simple wooden cross.

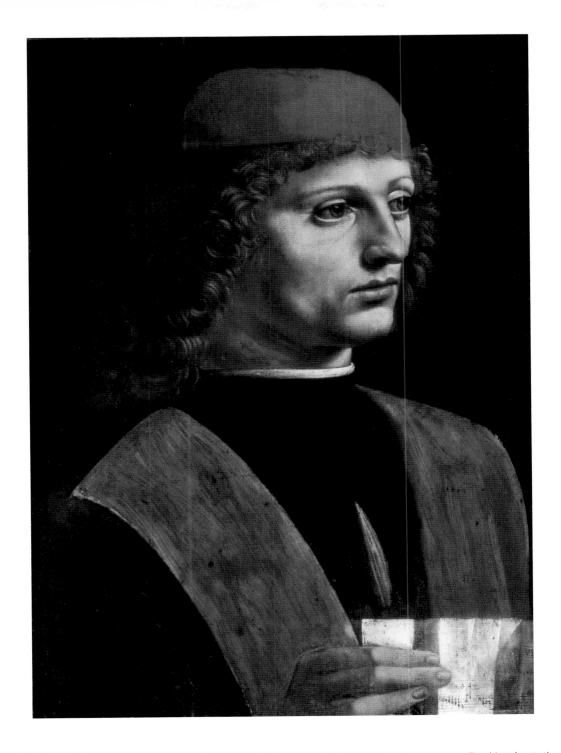

Disputed attribution This portrait of a musician was possibly the only portrait by Leonardo featuring a man. The title refers to the sheet of music in the sitter's right-hand, which came to light during cleaning in 1906.

Formally, Leonardo's *Mona Lisa* was based on the popular contemporary Madonna type, like this traditional household devotional image by an unknown artist.

viewers' position vis-à-vis the picture, her eyes still look at them directly. With the sitter's seated pose, her respectfully crossed hands and the unnaturalistic landscape background, the painting deviates from Italian portrait tradition. Formal parallels with Madonna images go back to the idea of the Virgin as the repository of all Christian virtues for the properly educated woman. The dark clothing indicates not only contemporary fashion — black is also associated with a number of exemplary characteristics. Even the way Lisa holds her hands is quintessentially moral, and thus to be interpreted as conforming with social norms.

As in previous works (for example in dispensing with halos in the first version of the *Virgin of the Rocks* and the *Last Supper*), Leonardo makes no use here of explicit symbols such as occur frequently in Renaissance portraits. He endeavours to show us character and virtues by inherently visual means — combining physical beauty with subtle variations of light and shade. Leonardo's technique of *sfumato* is evident in the blurring of Lisa's outlines, so that her figure blends into the background, while the rocks in the background seem in turn to merge with the blue-green sky.

The sculptor

In 1489, Ludovico Sforza commissioned Leonardo to execute an equestrian statue as a memorial to his father, Francesco Sforza. Early drawings indicate the initial artistic concept of a rearing horse (pp. 58, 59). This immediately created a problem of stability, since

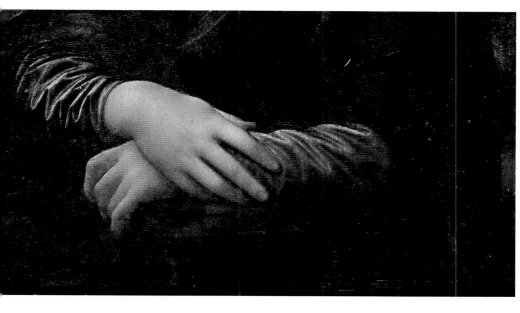

The pious crossing of the hands in the *Mona Lisa* is rare in the Italian tradition of portraits prior to c. 1500. It is more common in earlier Flemish portraits.

the two rear legs would have to carry the whole weight (an estimated 75 tonnes of bronze!) of the horse and rider. Leonardo appears to have dropped that idea, since later roughs show the horse trotting, as was the convention with equestrian statues. That was presumably also the pose in the clay maquette he made preparatory to casting the statue in bronze, which would have stood over 23 ft (7 m) high. Unfortunately, the maquette was destroyed during the conquest of Milan by French troops in 1499, and the bronze statue itself was ultimately never executed, since the duke deemed the military need for bronze more pressing.

A planned funerary memorial to the French-Italian military leader and Marshal of France Gian Giacomo Trivulzio also never came to fruition. Only studies of the anatomy of the horse and designs for a heroic equestrian statue dating from 1508–1510 indicate Leonardo's ideas on the subject.

The *Last Supper*

In the 1490s, Leonardo worked on the *Last Supper* at the refectory of Santa Maria della Grazie in Milan (pp. 38–39). The new treatment of the subject soon made the monumental painting — it measures 29 by 14.5 ft (8.8 by 4.4 m) — famous far beyond Italy's frontiers. Whereas in previous renderings of the Last Supper, Judas occupies a visibly excluded position, here he is among the Disciples. Another innovation is the great distance between Jesus and St John (in Leonardo's painting, the third Disciple from the left). Traditionally, he is shown leaning against Jesus. Finally, Leonardo abandoned the customary arrangement of the Apostles sitting statically next to each other, opting instead for four dynamic groups of three figures each.

The painting combines the two events of the Last Supper: the announcement of the imminent betrayal by Judas and the institution of the Eucharist. Ernst Gombrich called Leonardo's *Last Supper* "a study in shock," focusing on the reactions of those present to

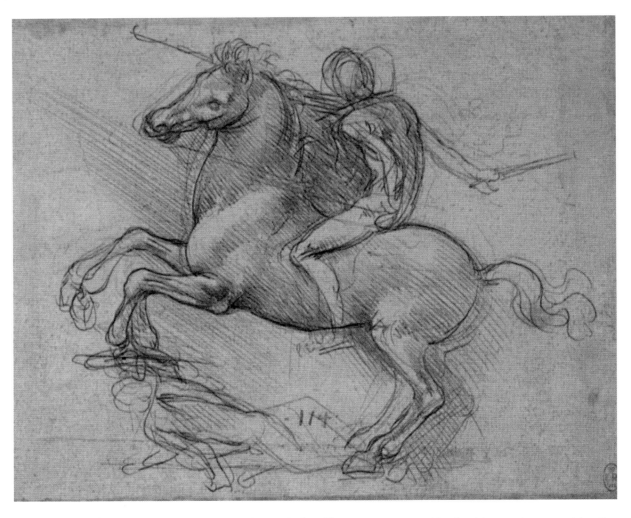

Jesus's words "Verily, I say unto you one of you shall betray me." In his physiological and anatomical studies, Leonardo thought he had found a way to show the inner workings of man externally. And it is true that the figures, with their gestures and differentiated facial expressions, convey individualised feelings and emotions — in the artist's words, "the movements of the soul" (p. 60).

The German poet Goethe summed up the drama of the scene as follows: "James the Great leans back in alarm, throwing wide his arms and staring in front of him, his head lowered like one who thinks he can see with his eyes the monstrous thing he has just heard.

Thomas appears at his shoulder, and, approaching the Saviour, raises the index finger of his right hand to his forehead. Philip, the third of this group, rounds it off quite charmingly. He stands up, stoops towards the Lord, and with hands on heart says with great distinctiveness: "Lord, it is not I! You know that! You know my pure heart. It is not I!"

St Anne

Another subject also kept Leonardo busy for the first decade of the 16th century — Mary and her mother, Anne. Around 1501, the Florentine church of Santissima Annunziata, the mother church of the Servite Order, commissioned a cartoon that aroused great excitement then

(Left and right) Studies of a rearing horse with rider, for the proposed Sforza monument.

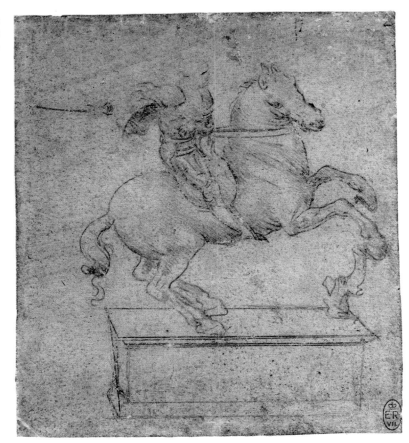

but has since been lost. What survives is the famous *Burlington House Cartoon* from 1508 now at the London National Gallery (p. 86, left), though this differs from the previous cartoon in the composition of the family group. A highly expressive drawing, done in charcoal and white chalk, it shows four figures arranged in the form of a pyramid, demonstrating Leonardo's liking for compositional harmony. The infant Jesus leans towards St John to bless him, creating a spiral movement which draws the viewer in. It begins at the head of Jesus, continues around the heads of the two seated women and along Mary's arm, ending in St Anne's finger pointing heavenwards. The spiral movement is even more evident in Leonardo's late figure composition *St John the Baptist* (p. 98). The heavenward-pointing finger recurs here, indicating the coming of Christ. The enigmatic character of Leonardo's paintings is more evident here than perhaps in any other of his works.

Around 1510, the King of France commissioned a painting on the same subject — the *Virgin and Child with St Anne* now in the Louvre. In 1913, Freudian psychoanalyst Oskar Pfister discovered a bird in the folds of her robe. Following an incorrect reference in Freud's study of Leonardo's childhood memories (see pages 102–103 for more on this), he discerned a vulture in it (p. 22). The

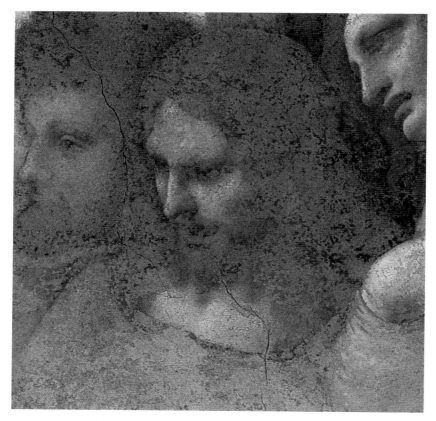

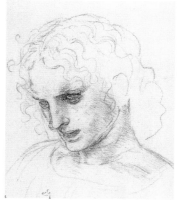

(Left and below) James the Great. Detail from Leonardo's *Last Supper* and preparatory study.

outlines of the bird appear most clearly if you tip the picture on its right side. Whether purely accidental, intentionally or unintentionally incorporated into the work, once seen it is difficult not to see it any more.

At the beginning of the new century, Leonardo worked not only on devotional pictures, portraits, church pieces and works with mythological subjects but also on a history painting. Planned to occupy a 56 by 23 ft (17 by 7 m) space on a wall in the Palazzo Vecchio together with Michelangelo's *Battle of Cascina*, Leonardo's *Battle of*

Anghiari would have been one of the highlights of the Italian Renaissance. But shortly after Leonardo began work on the commission, the fresco began to disappear in front of his eyes due to his using a new, untested painting technique, just as had happened in the *Last Supper*. When Vasari altered the architecture of the room a mere 60 years later, the final remnants of the fresco vanished. However, we have sketches which enable us to reconstruct the overall concept, which shows that Leonardo's battle painting was a symbolic representation of violence in war. The image of terror is

Study of drapery from the series of preliminary drawings for the painting *Virgin and Child with St Anne* (p. 22).

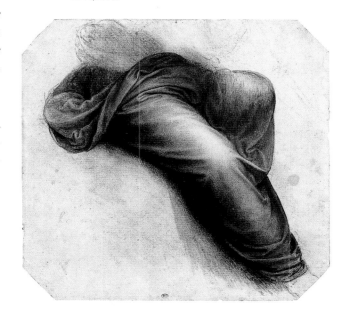

particularly evident in the copy of a section done by Rubens showing the bestially distorted faces of men (p. 27). They recall Leonardo's studies of physiognomy and the grotesque heads with which he pioneered the rendering of human features with graphic techniques.

In his writings, Leonardo ranks painting ahead of all other arts such as sculpture, literature and music, seeing it as a synthesis of all sciences. It was an importance never previously accorded to painting.

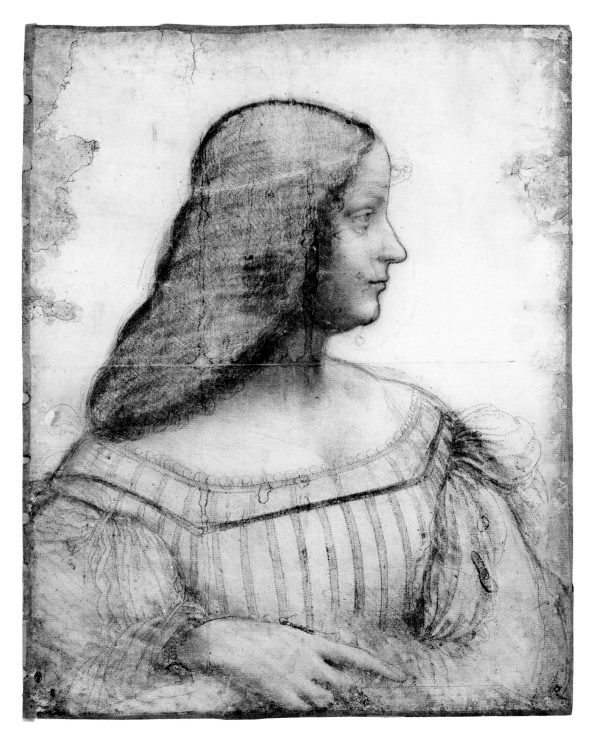

Portrait of a Young Woman in Profile Leonardo's drawing of Isabella d'Este in black chalk and sanguine was executed during his stay at her court in Mantua from 1499 to 1500. The drawing anticipates a number of features of the *Mona Lisa*, such as the hair apparently contained in a veil, the pose of the sitter and her crossed hands, though the latter are no longer complete here following a later cropping.

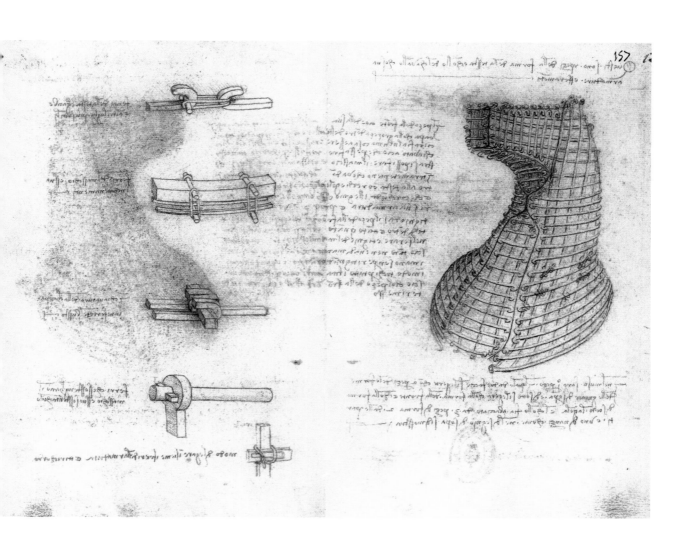

Technical drawings This sketch of an armed matrix for the equestrian statue of Francesco Sforza documents Leonardo's efforts to develop a new casting procedure. Contrary to accepted practice, he had decided to cast the horse as a single piece. It was only in the 17th century that the technique he invented was taken up again to produce an equestrian statue of Louis XIV.

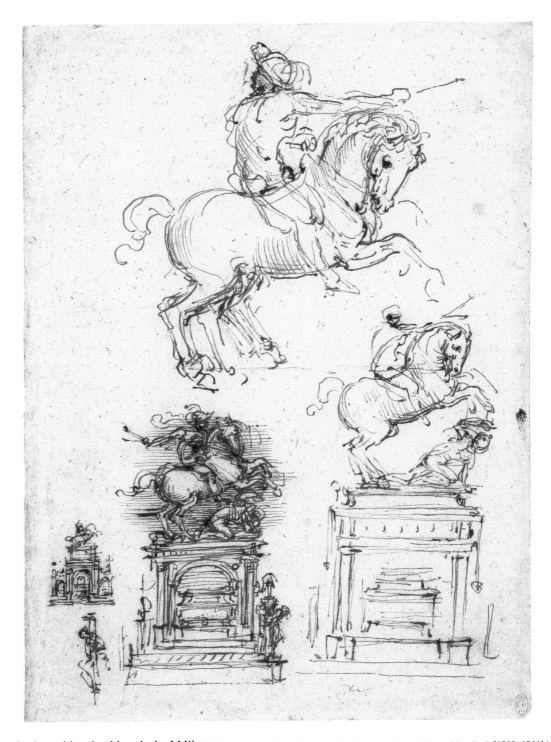

Commissioned by the Marshal of Milan Numerous studies of horse and rider on a decorated marble plinth (1508–1511) bear witness to Leonardo's work on the tomb of Gian Giacomo Trivulzio in the basilica of San Nazaro Maggiore in Milan. The project is thought not to have got beyond the planning stage.

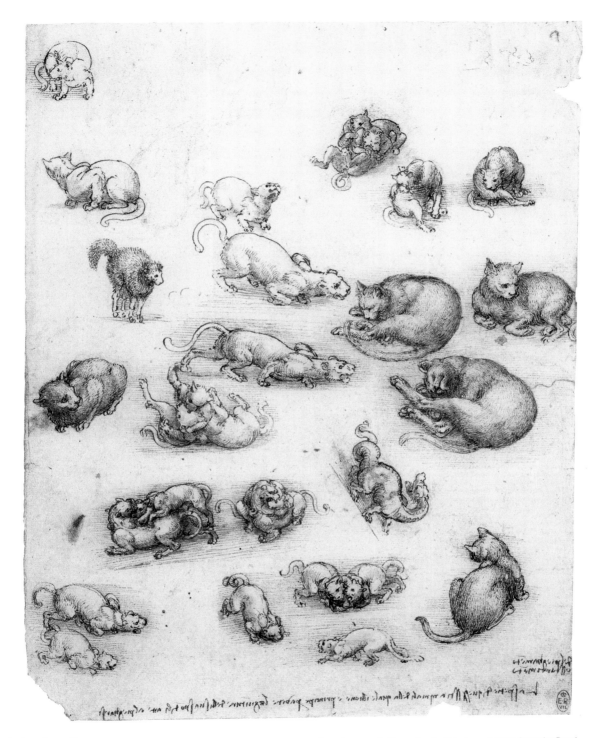

Animal studies Leonardo's manuscripts are full of drawings of horses, dogs, bears and other animals. This famous page from the Royal Library in Windsor from 1513–1516 features various studies of cats, though if you look carefully, one of them is a dragon.

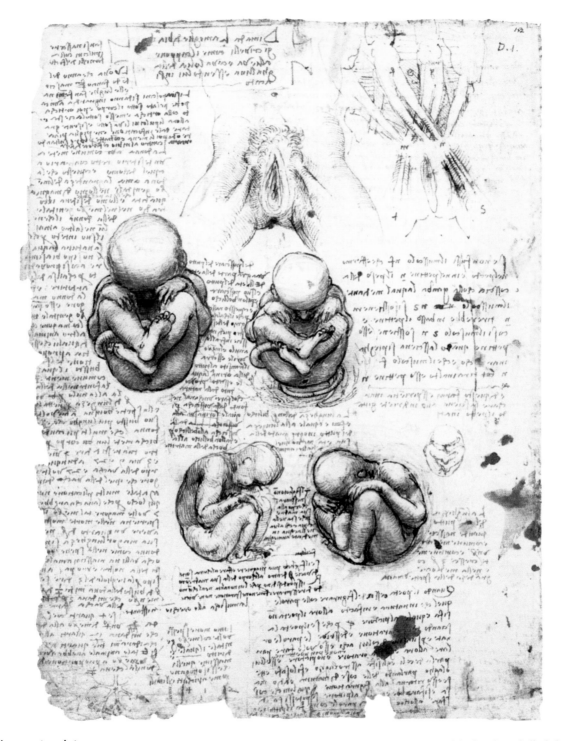

The anatomist Leonardo did a number of studies of foetuses and also of the structure and dimensions of the female genitalia. In his notes, he raises the theological question of the soul of the unborn child, and decides it is not a separate entity as it is completely dependent on the body and soul of the mother.

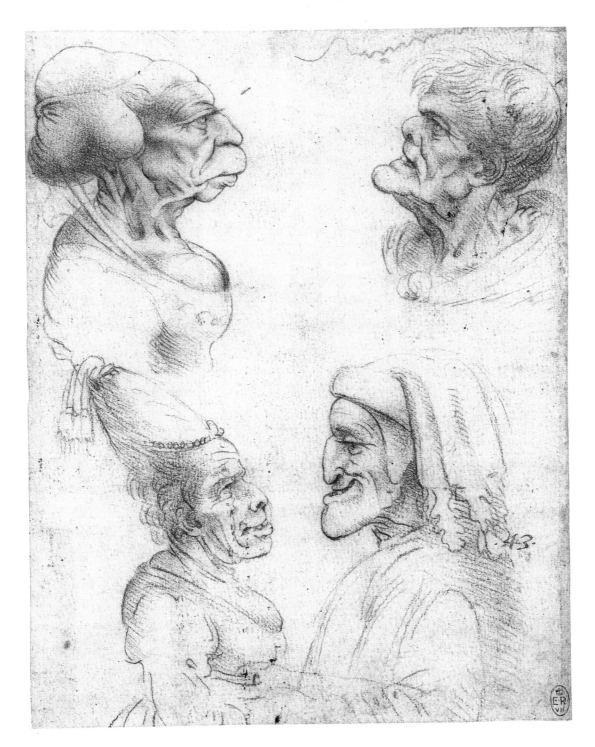

Caricatures In the 1480s and early 1490s, Leonardo drew a series of grotesque portraits, mostly faces of old men and women. A contemporary tells of a notebook that the artist always carried on his belt. Among the grotesques are also celebrities such as Dante (bottom right). These drawings are by Francesco Melzi after originals by Leonardo.

Life

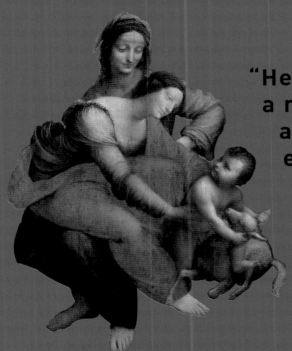

"He was like
a man who had
awoken too
early in the
dark, while
the others were
still asleep."

Dimitri S. Merezhkovsky
on Leonardo da Vinci, 1901

Vinci, 1452 ...

"A grandson, the son of my son Ser Piero, was born to me on the fifteenth day of April, a Saturday, around the third hour of the night. He bears the name Lionardo."

The codices

The key documents for our knowledge of the life of Leonardo are the extensive manuscripts written in his own hand — notebooks, collections compiled after his death and individual sheets. Around 7,000 pages survive to this day. It is very probable that thousands more have been lost.

Leonardo's whereabouts

--→ **Vinci, near Florence (b. 1452)**

--→ **Florence (initially training in Verrocchio's workshop)**

--→ **Milan (mainly at the court of Ludovico Sforza)**

--→ **Periods in Mantua, Florence, Venice, Rome, Milan**

--→ **The Château Clos Lucé in Amboise, France (d. 1519)**

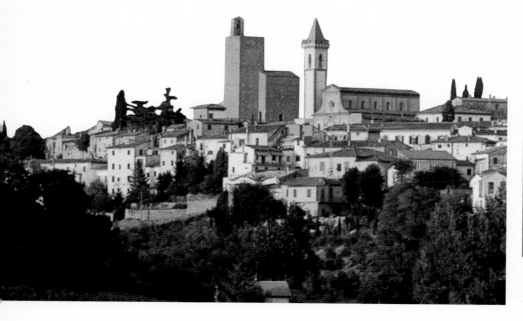

The small town of Vinci in Tuscany, with the church of Santa Croce, where Leonardo was baptized.

Historical sources

Another important source for discovering the life and personality of Leonardo are contemporary or near-contemporary documents, particularly the brief biographies by:

- → **Antonio Billi** (c. 1480–1550), Florentine merchant
- → **Paolo Giovio** (1483–1552), Lombard historian, physician, emblematicist, Bishop of Nocera (he was probably personally acquainted with Leonardo)
- → **Giorgio Vasari** (1511–1574), architect, writer, Medici court painter (left)
- → **Giovanni Paolo Lomazzo** (1538–1600), Milanese painter and writer. Personally knew Leonardo's executor, Francesco Melzi.
- → An unidentified author known as Anonimo Gaddiano.

Notes in mirror script

Leonardo wrote his notes in mirror script. The lines run from right to left, with every letter back to front, which makes reading the notes laborious. There has been much debate about this. Was it simply that Leonardo was left-handed and this was just a spontaneous expression of his flow of thought? Or was he trying to keep his ideas and thoughts secret from prying eyes?

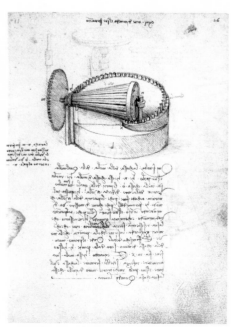

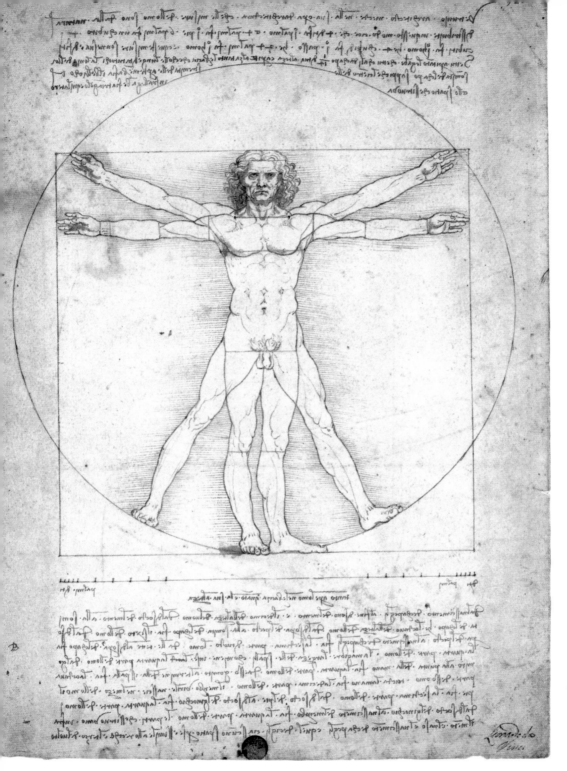

The *Vitruvian Man* is the best-known of Leonardo's studies of human proportions, and is also a trademark of his universal cast of mind.

The house where Leonardo was born is in the locality of Anchiano, near Vinci.

The Eternal Search for Knowledge

Was there a discipline in which Leonardo was not interested, or in which he did not try to become a specialist? His manuscripts bear witness to his tireless search for answers to a constant flow of new questions about the appearance of things. They reveal the great adventures of art and science to which he dedicated his life.

Leonardo was born in the little town of Vinci not far from Florence, presumably in the locality of Anchiano. His father, Ser Piero di Antonio da Vinci (*Ser* was the honorific for lawyers and notaries) had, like his ancestors for three generations back, taken up the profession of notary, and had been successful. Leonardo's mother Caterina came from a simple family. Being illegitimate, Leonardo presumably spent his first years with his mother until Caterina married, but was then taken in by Ser Piero, who had likewise married meantime.

"He dissected corpses of criminals in the anatomy schools of the physicians, indifferent to the inhuman and disgusting sights."

Paolo Giovio,
c. 1523–1527

73

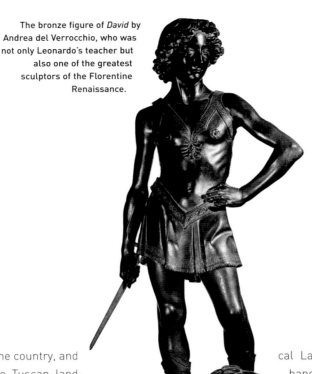

The boy grew up in the country, and his deep love of the Tuscan landscape is evident in many of his later paintings. His "great love and patience" in his dealings with animals is almost a cliché these days, and is cited by his early biographers as an example of his irreproachable character. Vasari, for example, says: "Often, when he went by places where birds were being sold, he took them out of the cage, paid the price asked for and let them go, restoring to them their lost liberty." His natural sympathies with animals could also account for his vegetarianism, which is documented with certainty at least in his later years, and the numerous drawings of animals, particularly horses.

The self-taught scientist

After attending elementary school, Leonardo went to the *scuola d'abaco* (counting school) until his fifteenth year, where he was vocationally trained. As he was illegitimate, the university-oriented *scuola di lettere* was out of bounds to him. He thus learnt virtually no classical Latin, which in adult life proved a handicap as his intellectual ambitions developed. The language was the basis for academic knowledge, since virtually all important scientific and literary texts of classical antiquity and the Middle Ages were available only in Latin. When he was almost 40, Leonardo sought to remedy this gap in his knowledge, as detailed lists of words in his notes bear out.

Leonardo did not regard his inadequate education as a disadvantage but liked to emphasize that he had acquired his knowledge by observation and practical experience. "I am well aware that many an idle jackanapes will think that, because I'm not a savant, he can justly criticize me. … Do they not know that what I have to say is drawn not from the teachings of others so much as from experience?" Unfortunately, however, in the field of the sciences his lack of systematic thought does show through. Although his investigations strove for universal

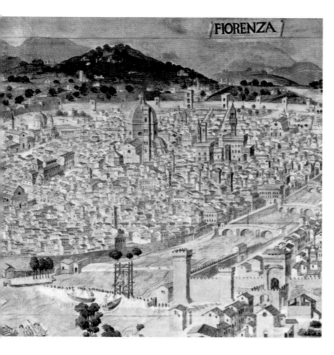

View of Florence, c. 1472.
In the centre is Florence's
famous cathedral, Santa
Maria del Fiore (p. 8).

knowledge, they read like a series of individual observations and experiments lacking an over-arching framework. Yet, at the same time, his independence from prevailing academic theories enabled him to cross frontiers with extraordinarily fruitful results, though he was of course prone to make mistakes as well.

Beginnings in Florence — Verrocchio's workshop
After leaving school, Leonardo went to Florence, where he entered the workshop of Andrea Verrocchio as a trainee and acquired a comprehensive artistic training. Among other pupils in the workshop were ambitious young artists of the period such as Sandro Botticelli, Perugino and Lorenzo di Credi (who subsequently ran the workshop from 1485). Unlike numerous other masters, Verrocchio never specialized but worked as a sculptor, goldsmith, painter and presumably also as an architect and structural engineer. Verrocchio & Co. was a successful small business where works of art were often turned out as joint efforts. But there are also works done by Leonardo single-handedly, like the well-known

Arno Landscape, which is considered his earliest dated drawing and is thought by some to be the first purely landscape image in Western culture (p. 78).

Once his training was finished, Leonardo was admitted to the painters' guild in Florence. The guild archives record the admission of other new painters that same year: Botticelli, Perugino, Domenico Ghirlandaio, Filippino Lippi, and the Pollaiuolo brothers — in fact, some of the most talented Florentine painters of the late 15th century. Leonardo continued working as an apprentice and assistant in Verrocchio's workshop. A first intimation of an independent career is a contract dated January 1578 for an altarpiece for the chapel in the Palazzo Vecchio, which he never actually delivered. It was the first of many works he never carried out. Paintings from this early period in Florence include the *Madonna with the Carnation*, the *Benois Madonna*, the portrait of *Ginevra de' Benci*, the *Adoration of the Magi* and *St Jerome*, the last two remaining unfinished.

Leonardo worked for about a decade for Duke Ludovico Sforza at the Castello Sforzesco in Milan.

Milan

Presumably in 1482, Leonardo left Florence, bringing a decade of sustained creativity to an end during which he had become a master of the Florentine School. Going to Milan was making a new start, although Milan had nothing to compare with the progressive art output of Flor-ence. Yet Duke Ludovico Sforza had set himself the ambitious target of creating a Milanese equivalent. Ludovico il Moro (the "Moor" epithet came from his swarthy complexion) ransacked Italy for architects and artists to bring to Lombardy, including architect and painter Donato Bramante from Urbino, who soon became a friend of Leonardo's.

Leonardo sent a letter of self-recommendation to the duke in which he confidently listed the skills he had to offer — particularly as an inventor of military machines and technical devices. It was a major reorientation if one bears in mind that in Florence he had worked almost solely as a painter. But his application made sense, since at the time Milan was at war with Venice. Military expenditure accounted for about 70 percent of the Sforza regime's outgoings. Only at the end did Leonardo mention his artistic skills, particularly with reference to the equestrian statue he had been planning for years but never executed: "In addition, I will undertake to execute the bronze horse which will be to the blessed memory of my lord Your Father and bring immortal fame and everlasting honour to the illustrious house of Sforza." Perhaps that was the actual underlying impetus behind his application to the court. The great equestrian statue of Francesco Sforza would keep Leonardo busy for nearly two decades.

Entertainment at court

Alas, he had to wait years for the court position he had hoped for. His first major contract in Milan came not from the duke but from the Confraternity of the Immaculate Conception, to create a painting for their new chapel in the Franciscan church of San Francesco Grande. The result was the *Virgin of the Rocks*, the most important painting of this early Milan period (p. 89).

In the centre of the ceiling of the Sala delle Asse, which Leonardo decorated in the tower of the Castello Sforzesco, is the combined coat of arms of Ludovico Sforza and Beatrice d'Este.

Around 1490, Leonardo finally began work as an official organizer and planner of festivities at the Castello Sforzesco. His duties as *apparatore* or master of ceremonies included the arrangements for the important double wedding of Ludovico Sforza with Beatrice d'Este and his niece Anna Sforza with Beatrice's brother Alfonso d'Este. Leonardo also did the staging for plays, designing scenery, masks and costumes. Historiographer Paolo Giovio praised Leonardo as an "inspired inventor, organizer of dramatic sets and processions. He was considered the ultimate judge in all matters of elegance and beauty. And what is more, he sang beautifully ... accompanying himself on the lute." Leonardo's musical abilities are mentioned in other sources, especially his outstanding command of the *lira da braccio*, a bowed instrument resembling a violin. His estate contained many drawings of musical instruments, together with his ideas for improving and automating their use.

Leonardo also revealed a gift for the showmanship the court required, and his other duties expanded accordingly. He wrote fables, puzzles, jokes, allegories and *imprese* (devices combining an image and recondite mottoes), presumably to be recited at court. His abilities as a painter were also in demand. Shortly before Ludovico's wedding, he did the portrait of the duke's mistress Cecilia Galleriani, around the time that he admitted the

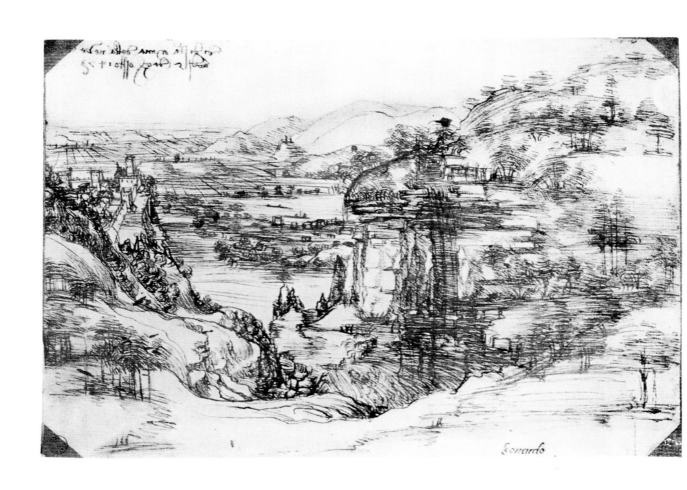

Arno Landscape Leonardo's earliest dated drawing is now in the Uffizi in Florence. Drawn with pen and ink on a sheet measuring 7.4 by 11.2 in (19 by 28.5 cm), it was dated by Leonardo 5 August 1473 in the top left corner. The scene is reminiscent of the landscape around Vinci.

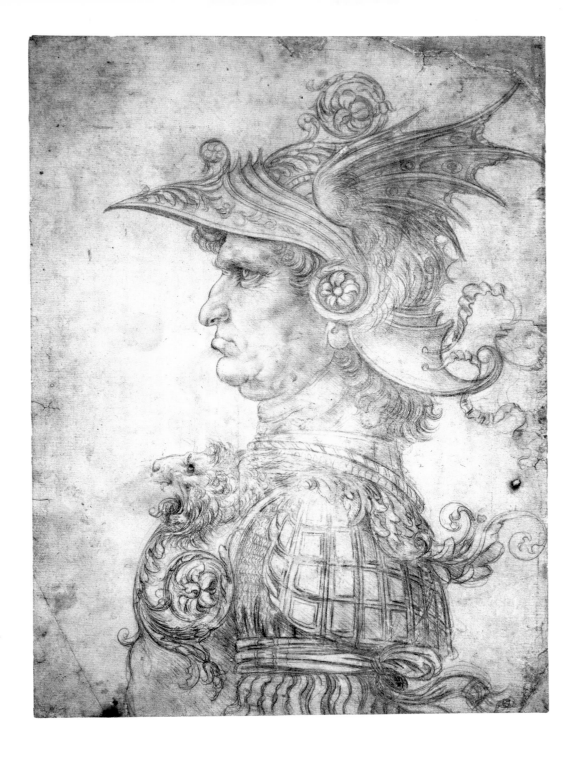

Variations of a facial type Leonardo's profile bust of a warrior has rather a strange role in Leonardo's drawn oeuvre — the distinctive facial features of the warrior recur in various works, showing him at different ages, with different hairstyles and from varying points of views.

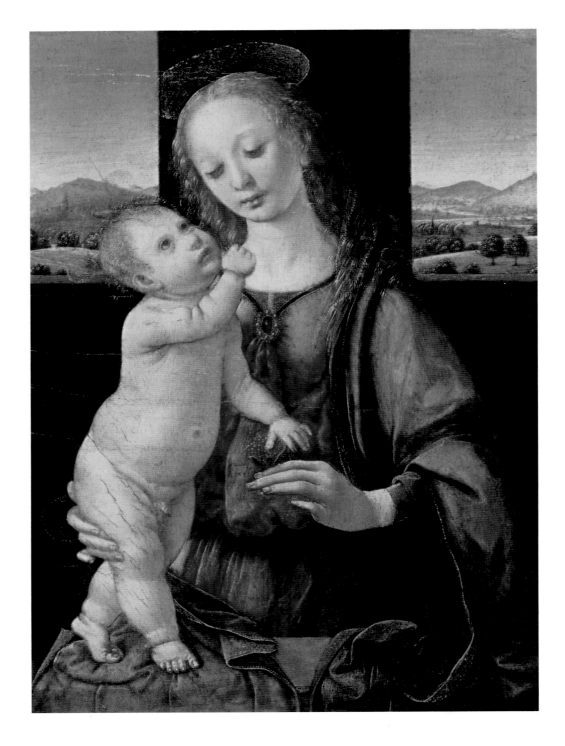

A genuine Leonardo? The *Dreyfus Madonna* was first ascribed to Leonardo in 1929, but the attribution has been disputed ever since. The National Gallery of Art in Washington still exhibits the work as by Lorenzo di Credi, who modelled his style on Leonardo's.

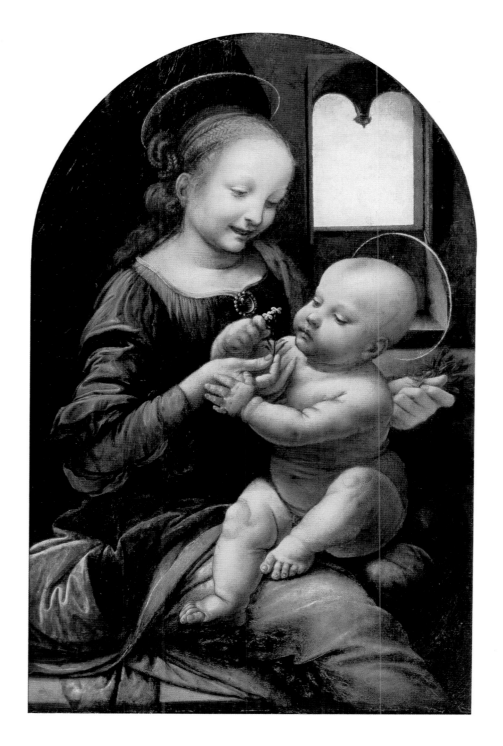

Absorbed in each other The *Benois Madonna*, named after a former owner of the painting, dates from Leonardo's early Florentine period. The empty window in the background is puzzling — was it a trick by the artist, or was something possibly subsequently covered up that can no longer be reconstructed?

This portrait by the School of Leonardo's presumably shows the young Beatrice d'Este, who married Ludovico Sforza, 25 years her senior.

wayward apprentice Salai to his household. Some years later, another Sforza mistress, Lucrezia Crivelli, probably also had her portrait painted by Leonardo, *La Belle Ferronière* (the identity has not been firmly established) (p. 90).

The artist of the *Last Supper*

Il Moro also commissioned the important *Last Supper* painting for the refectory of the monastery of Santa Maria delle Grazie. As a nephew of its prior, 12-year-old Matteo Bandello had an opportunity to watch Leonardo at work. In an artist novella written a decade later, Bandello — one of the most important novella writers of the 16th century — commented: "He arrived early, clambered up the scaffold and started work. Sometimes he remained from dawn till dusk, without ever putting down his brush. He forgot to eat and drink, and painted without interruption. At other times, he didn't touch the brush for three or four days but spent several hours a day in front of the work, his arms akimbo, examining the figures and criticizing them to himself." Vasari tells an

anecdote about the prior's discontent with this periodic "inactivity" of the master and his complaint to the duke about the slow progress of the painting. Leonardo responded with some annoyance that all he needed was a model who was base enough to serve as Judas. But if he couldn't find one, he could at any rate use the features of the importunate prior as a model. Ludovico was amused at Leonardo's reaction. Rebuffed, the prior returned to his gardening and from then on left Leonardo in peace.

Scientific studies

Leonardo's stay in Milan would turn out to be his most productive period in all fields. The appointment at court guaranteed him an income and involved performing various different tasks, including military projects, designs for a new city solving the sewer problem, and architectural drawings. This still left time to follow his own interests such as his technical inventions and scientific studies, which influenced and enriched his artistic work.

Leonardo's figure studies of women dancing are a reminder of his appointment as master of ceremonies at the court in Milan.

That included his research into the human body. For Leonardo, anatomy — like mathematics and geometry — was one of the fundamental disciplines of painting, which constituted the starting point of his multifarious interests. He studied ancient sculptures and anatomical texts, and in the late 1480s began to dissect animal and human corpses. A note he wrote about these makes clear the obstacles he had to overcome and the repugnant circumstances in which the dissections must have taken place: "And even if you have an inclination for these things, nausea may keep you from them, and if that doesn't, then perhaps the fear of spending the night in the company of dismembered, flayed and horrible looking corpses will do so." The work was made more difficult not only by the unhygienic conditions of the time and the lack of an effective refrigeration process — dissections of the human body were also associated with all sorts of superstitious notions that brought him into conflict with the Church. But, nonetheless, the outcome was anatomical drawings that were far more accurate than any previous attempts in this field.

During his research, Leonardo produced a list of questions that highlight his hunger for a comprehensive understanding of phenomena:

"Which nerve moves the eye causing the other eye to move at the same time?
Closes the eyelids
Raises the eyebrows
Lowers the eyebrows
Closes the eyes
Opens the eyes
Flares the nostrils
Opens the lips with clenched teeth
Purses the lips
Smiles
Expresses astonishment.

Experiments to describe the origin of human life in the womb
and why an eight-month old child fails to survive
What sneezing is

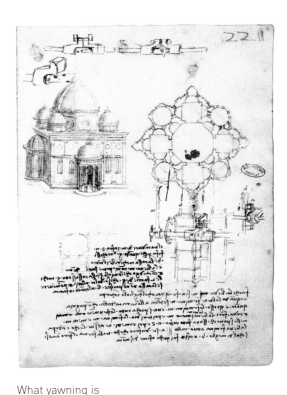

Design for a central-plan church, with an altar in the central octagon.

What yawning is
Falling sickness
Convulsions
Paralysis
Shivering
Fatigue
Hunger
Drowsiness."

Leonardo always went into things in depth. He wanted to get to the bottom of everything.

Experiments in the technical field

His duties at court included doing designs for military projects or structures for fortifications and the theatre. Leonardo left us a whole variety of technical drawings that are fascinating in their modernity, detail and aesthetic quality. He sketched machines that had already been constructed, like the famous hoist Brunelleschi designed for the dome of Florence Cathedral. Likewise he carried out his own research into the laws of me-

chanics, attempting thereby to arrive at a technology. This includes his drawings of machines for the more effective organization of work by automating mechanical production processes. However, some of his designs are pure fantasy and quite impracticable. For years, Leonardo worked on the development of a flying machine that would work by using human muscle power in imitation of bird flight. His studies failed as he could not come up with an adequate drive system to give uplift. Yet he managed to work out the importance of air resistance for the movement of bodies, and so was able to design the precursors of gliders, parachutes and helicopters. His work on air resistance was continued by Galileo.

An unsettled age

Painting the Sala delle Asse in the north-eastern tower of the Castello Sforzesco was his last commission from the duke (p. 67). When a French army led by Trivulzio and Ligny invaded Milan on 6 October 1499, Ludovico fled to Emperor Maximilian I in Innsbruck; after a brief Sforza reconquest, he ended up in French captivity. For

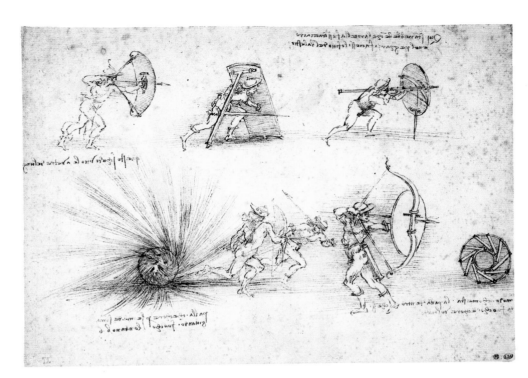

Study of soldiers'
shields and an
exploding bomb.

Leonardo, this meant the loss of his most important patron so far. At the same time, it meant an encounter with his patrons of later years, the French kings, and in their wake Cesare Borgia and Charles d'Amboise. When Louis XII commissioned a painting of St Anne from him, the first draft of which is probably the *Burlington House Cartoon*, Leonardo left the city. He spent a brief period at the court of the young marchioness of Mantua, Isabella d'Este, before moving on to Florence, Venice and Rome. Contemporary sources document his increasing reluctance to paint. Leonardo spent his time with mathematics, geometry and Latin, living chiefly off savings he still had from his Milan days.

In 1502, he entered the service of Cesare Borgia as an engineer and architect, Borgia being the illegitimate son and principal general of the infamous pope Alexander VI. In his capacity as technical adviser, Leonardo travelled about the Papal States in central Italy inspecting the construction of fortifications. Among other things to survive from this period is a detailed, finely coloured town plan of Imola, which is remarkable both for its elegance and its modernity of conception (p. 87).

Later stay in Florence

In 1503, Leonardo returned to Florence for the last time. While he was there, two other outstanding artists were briefly in the city at the same time — the young Michelangelo, who had just completed an early masterpiece, his *Pietà* for St Peter's in Rome, and from 1504 the 21-year-old Raphael. Contemporary biographers documented the mutual contempt that apparently Leonardo and Michelangelo felt for each other. Shortly after the latter had finished his huge *David*, the city's Building Office called together the city's principal artists and craftsmen — Botticelli, Filippino Lippi, Perugino, Lorenzo di Credi, Leonardo and others — to decide where the sculpture should be exhibited. Given the competitive pressure, it was clearly a situation that Leonardo found oppressive. The artistic competition between Leonardo and Michelangelo culminated in parallel

Sketch for the now lost painting *Leda and the Swan* (compare p. 91).

Leonardo's *Burlington House Cartoon* (compare p. 22).

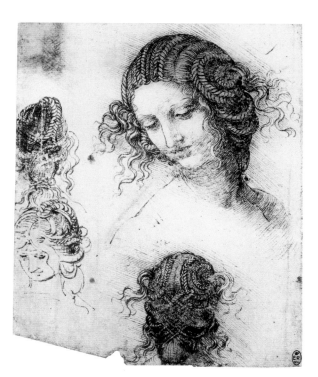

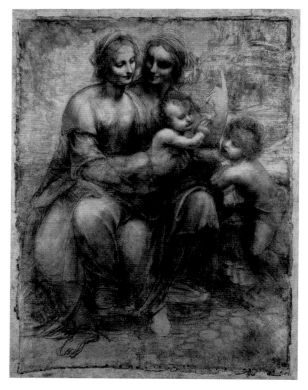

commissions for frescoes for the council chamber in the Palazzo Vecchio: the *Battle of Cascina* and the *Battle of Anghiari*, depicting great Florentine military victories over Pisa in 1364 and Milan in 1440.

The *Virgin and Child with St Anne*, the now lost *Leda and the Swan* and the legendary *Mona Lisa*, one of the few completed paintings of the late period, all date from this time. Leonardo drafted a plan for diverting the Arno for the city council — in 1503, Florence was at war with Pisa and wanted direct access to the sea.

The final years

In 1506, Leonardo left Florence again to return to Milan, presumably in connection with the technical difficulties he was experiencing in painting the *Battle of Anghiari*. As a result of experiments with an untried painting technique, the fresco was already peeling off the walls. He entered the service of the French king Louis XII under the aegis of the Governor of Milan, Charles d'Amboise, who was endeavouring to restore the former culture of artistic patronage. Thus among the projects Leonardo worked on was a design for the equestrian statue of the conqueror of Milan, Gian Giacomo Trivulzio.

In the end, the French themselves were driven out of the Lombard capital. In 1513, Leonardo accepted the invitation of Giuliano di Lorenzo de' Medici and went with his pupils, including Salai and Francesco Melzi, to Rome, moving into the Palazzo Belvedere in the Vatican. The brother of his new patron, in power as Pope Leo X, kept him busy with plans for draining the Pontine Marshes. While Michelangelo and Raphael were notching up huge

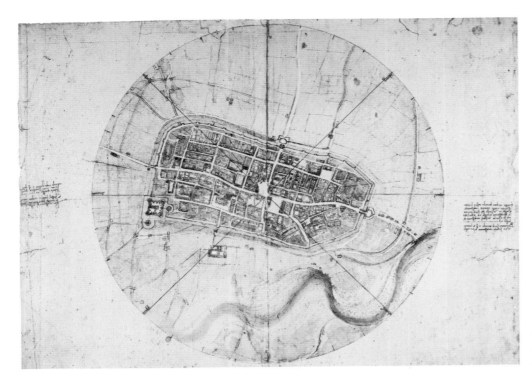

Town plan of Imola, one of Leonardo's best-known cartographical drawings.

successes in the new Italian art capital of Rome, Leonardo seems to have produced very little at this time. A late and possibly last painting was *St John the Baptist* (p. 98).

When Giuliano died of tuberculosis in 1516 aged barely 37, Leonardo set off on his longest journey to date, going to France and the royal court in the Loire Valley. The young French king Francis I had great respect and admiration for him. He made Leonardo the "principal painter, engineer, royal architect and royal expert in mechanics," and paid him a generous salary. In his last years at Château Clos Lucé near Amboise, Leonardo spent most of his time pursuing his scientific studies, irrigation projects and architectural designs, plus plans for a new château. In addition, he arranged court celebrations. Presumably he also had health problems to contend with, but it is not known how far these impaired or prevented his artistic activity.

Leonardo died on 2 May 1519 at the age of 67. As he had specified in his will, he was buried in the church of St Florentin in Amboise — for some reason, three months after his death. In 1802, the church was demolished, but the bones they found were not transferred to the nearby chapel of St Hubertus until 1874. His intellectual estate passed into the hands of Francesco Melzi. As custodian of part of his painted oeuvre and publisher of his numerous writings and drawings, Melzi gave posterity access to the extraordinary life of Leonardo da Vinci.

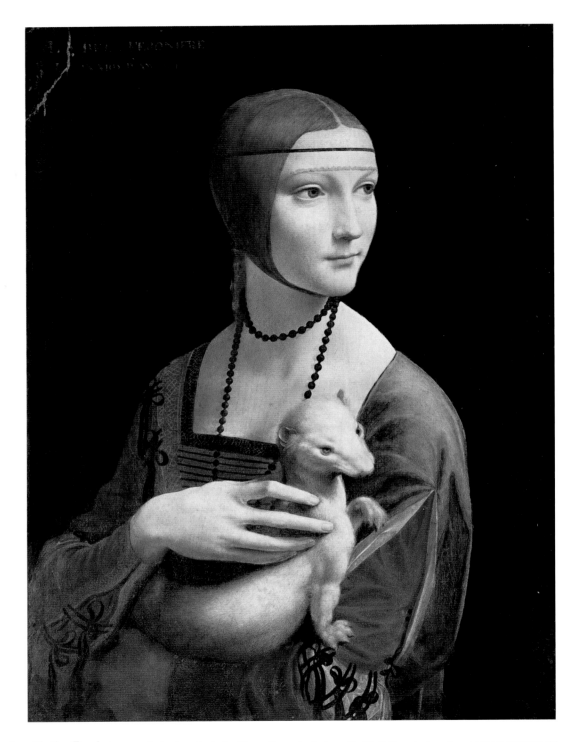

Lady with the Ermine A commission from Ludovico Sforza, the portrait shows Cecilia Gallerani when she was about 17 years old. The ermine (weasel) was considered a symbol of purity and cleanliness, while in its Greek form *galé* constituted a link with the sitter's family name.

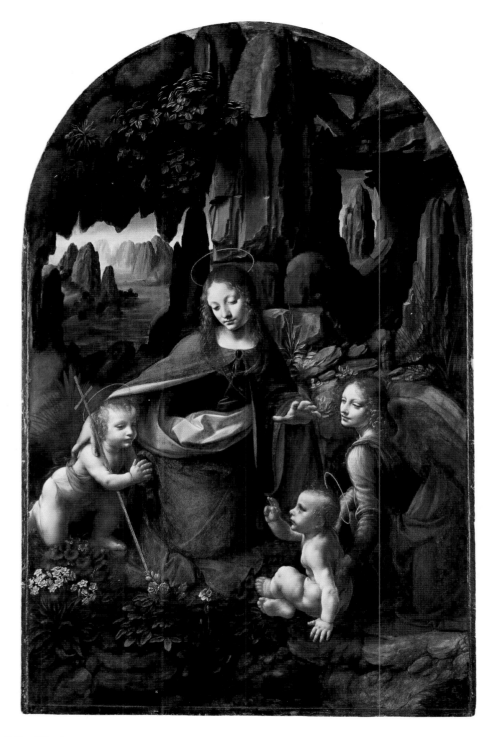

The cult of the Virgin Leonardo produced two versions of the *Virgin of the Rocks*. The above is the one at the National Gallery in London, with the added halos. As the centre panel of a large altarpiece, it was originally surrounded by various sculptures and reliefs with scenes from the life of the Virgin.

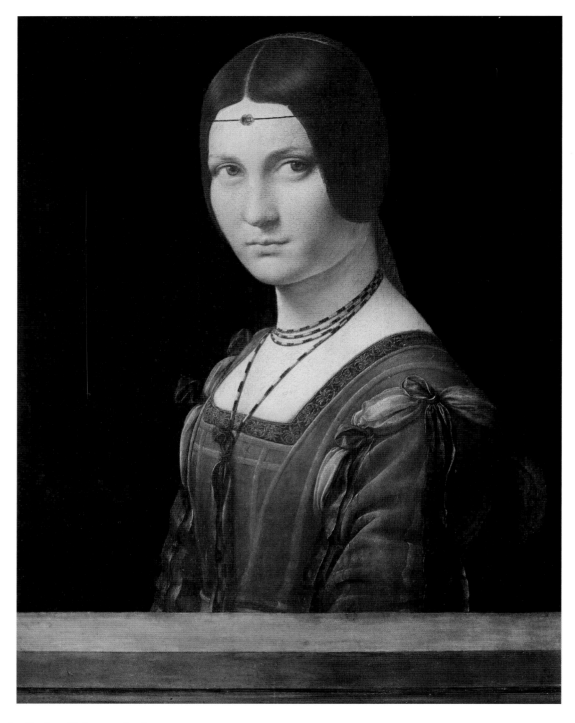

Portrait of an Unknown Lady Who was the sitter for the portrait of *La Belle Ferronière*? Many people assume that it was Lucrezia Crivelli, others say Beatrice d'Este (see p. 82). It is possibly another portrait of a somewhat older Cecilia Gallerani (see p. 88).

Classical mythology Leonardo's painting *Leda and the Swan* has disappeared, but can be reconstructed from sketches and copies. His interpretation of the subject focuses not on the sexual act between the young Leda and the Swan but on her position between the transformed Zeus and the pairs of twins produced by the liaison.

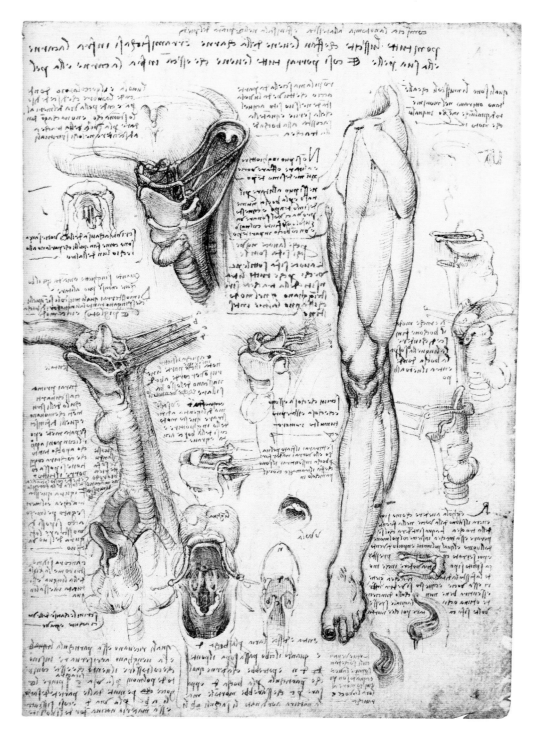

A "deep student" "I expected to see little more than such designs in Anatomy, as might be useful to a painter in his own profession. But I saw, and indeed with astonishment, that Leonardo had been a general and a deep student. When I consider what pains he has taken upon every part of the body, the superiority of his universal genius ... I am fully persuaded that Leonardo was the best Anatomist, at that time, in the world." Anatomist William Hunter, 1784.

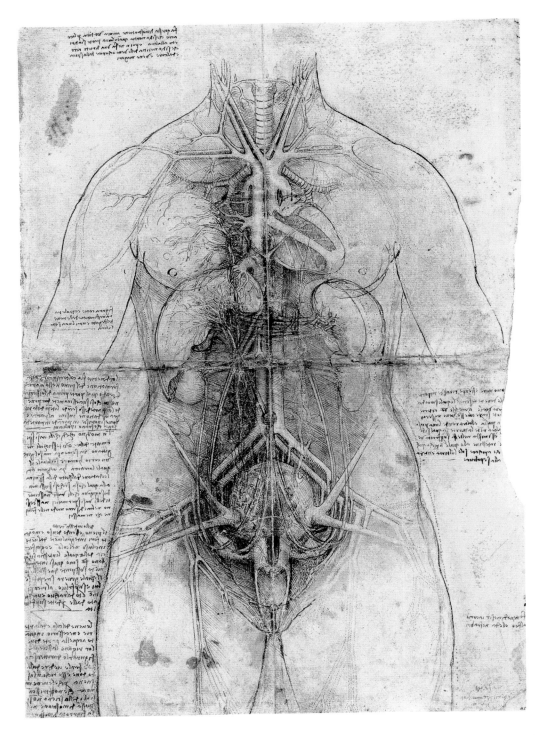

Symbiosis of art and science Striving for universal knowledge, Leonardo endeavoured to explore the human body in great detail. Though very perceptive and unprejudiced, his research did lead to mistakes, for example his assumption of a channel linking the breasts with the womb in the woman's body (p. 101).

Love

"Happiness
consists of
finding appropriate
moderation in a
life tending to
immoderation."

Leonardo da Vinci

Speculation about Leonardo's Love Life

You look almost in vain for any trace of human feeling in Leonardo's notes. Was there any human being who meant anything to him particularly? More than half a millennium after his death, these and similar questions can no longer be answered. Yet this has not stopped all kinds of speculations over the centuries.

"Little Devil"

Apart from his family, the lengthiest relationship Leonardo ever had was with Gian Giacomo Caprotti, whom he took on as a 10-year-old, as factotum, er-rand boy and model in summer 1490, with an eye to future training as a painter. Leonardo called him Salai, "Little Devil," and there is a detailed list of his petty and not so petty crimes in Leonardo's writings. Nonetheless, Salai remained with the master for 25 years, from Milan via Mantua, Venice and Florence to Rome. What connected Leonardo and Caprotti for such a long time?

Detail of a figure study for the
Adoration of the Magi (p. 52).

Leonardo's thoughts on love ...

-→ **"The greater the man, the more profound his love."**

-→ **"True knowledge always comes from the heart."**

-→ **"Where there is great feeling, there is also much sorrow."**

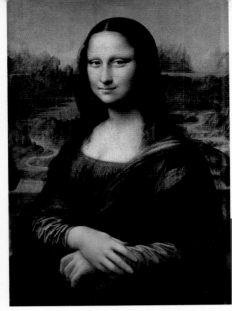

One of the most bizarre theories relating to Leonardo's most famous portrait is that the *Mona Lisa* was a self-portrait of the homosexual artist as a woman.

Homosexuality in Renaissance Florence

Even early biographers presumed that Leonardo was sexually attracted to other men. Homosexuality was well known in 15th-century Italy, and was particularly associated with Florence. Whereas the Medici openly flaunted the social and cultural practice of sodomy, it had always been condemned by the Church. In the eyes of the law, same-sex relationships between men counted as a capital crime punishable by death at the stake; in 1432, Florence was the first European city to set up a separate authority for prosecuting homosexuals. Over a period of 75 years, the Uffiziali di Notte investigated more than 10,000 cases, and convicted and sentenced around 2,000 men.

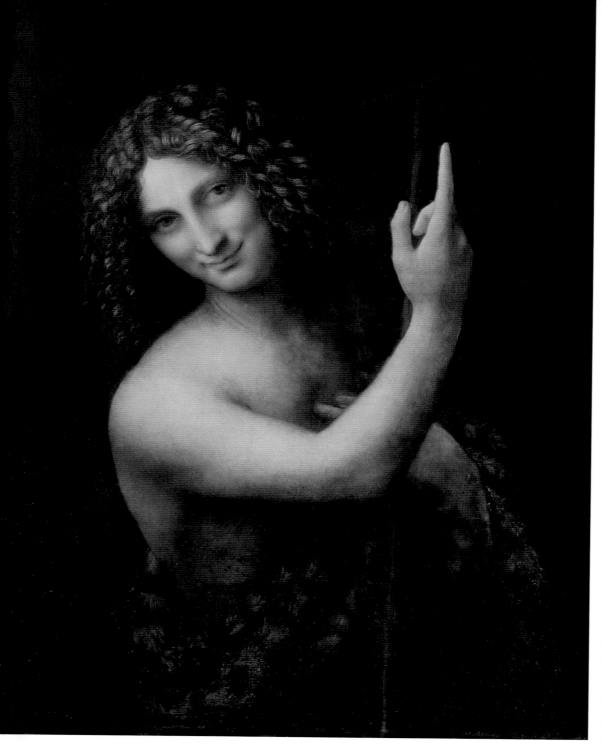

The androgynous figur
of St John the Baptist,
with long curly hair, an
enigmatic smile and an
ambiguous gesture, is
often cited as evidence
of Leonardo's sexually
orientation.

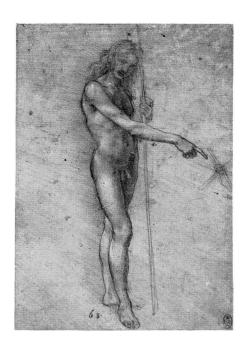

Study of a male nude
with a pilgrim's staff.

The Saltarelli Affair

In Leonardo's day, *tamburi* were installed around Florence that were supposed to act like the famous *bocca della verità* ("mouths of the truth") in Rome. They were letterboxes for people to denounce fellow citizens anonymously to the government for blasphemous or other sinful behaviour. In April 1476, one of these *tamburi* received a denunciation that would later excite biographers and Leonardo scholars.

The anonymous informant accused a certain Jacopo Saltarelli, a 17-year-old goldsmith's apprentice, of "numerous indecent actions." It said that he "willingly satisfies the wishes of people who demand sinful things from him. In this way, he has done many things, i.e. he has serviced many dozens of people I know of, some of whom I name here." There followed a list of four men, including "Lionardi di Ser Piero da Vinci, residing with Verrocchio." Leonardo was 24 at the time.

> "An insight that has not passed through the senses can produce no other truth than a harmful one."
>
> **Leonardo da Vinci**

Nude studies by Leonardo based on Michelangelo's monumental statue *David*.

Around two months later, a court hearing took place, but the charges against the accused were subsequently dropped and the proceedings discontinued for lack of evidence. Among those charged was a relative of the influential Medici, possibly a reason for the proceedings being dropped.

In Leonardo's writings, there is only a single note that may relate to this affair: "When I painted the Lord God as a boy, you locked me up in prison. Now when I show him as a mature man, you would do even worse things to me." Leonardo was possibly talking here about the young Saltarelli as his life model, a circumstance which took him briefly into custody.

No evidence of any kind

The *tamburi* system made it easy to accuse anonymously anyone you disliked without having to produce evidence. At the same time, the denunciation could indeed refer to Leonardo's homosexual inclinations. There are a number of allusions to the subject in the early biographies of him. Vasari presumed a same-sex relationship with his "favourite assistant" Gian Giacomo Caprotti, whom he describes as a "graceful, well-formed a youth with curly hair … in which Lionardo took peculiar pleasure." Painter, art historian and writer Giovanni Paolo Lomazzo was even more explicit. In a manuscript of the early 1560s, he sketched out an imaginary dialogue between Leonardo and classical sculptor Phidias on the subject of Salai: "Have you ever done the 'bum game' with him, which the Florentines like so much?" asks

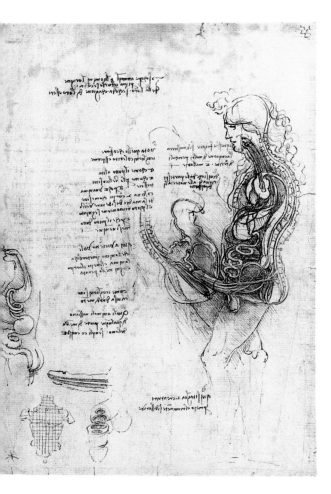

Leonardo's celebrated anatomical study of sexual intercourse.

Phidias, and Leonardo answers: "Many times. You should know that he was a very beautiful boy, particularly when he was 15."

In present-day Leonardo scholarship, the artist's homosexuality is evident to many. Small clues in Leonardo's notebooks are as indicative as the preponderance of male nudes by him and also the results of psychological investigations of his works. For example, the famous drawing *Cross-section of a sex act* shows the male body almost fully drawn, whereas the woman is indicated only by the abdomen and breast. The man is represented with female features, and has long curly hair. Bottom left on the sheet is another male person in section, with a penis alongside aimed at his buttocks. Clearly, homoerotic associations would naturally arise with such a scene. It is just the same with a drawing showing an angel with an erect penis. But debate also continues about the androgynous element in Leonardo's figures, especially in relation to his painting *St John the Baptist*.

An autobiographical note and psychoanalytical interpretations

Leonardo himself reveals virtually no interpersonal feelings or anything about his relationship with men or women. This makes a number of hastily written personal thoughts such as a small note in the margin of a manuscript at a time when Leonardo happened to be intensely preoccupied with bird flight, all the more important: "To write of the kite in such detail seems ordained by fate since it is present in my first recollection

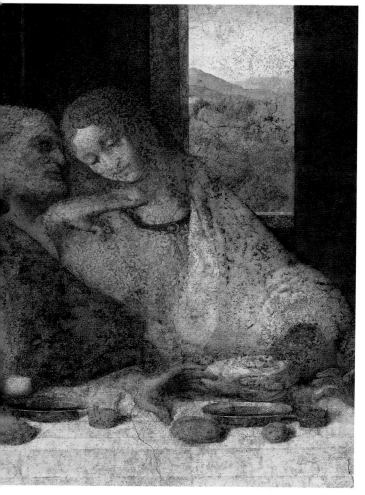

of my childhood, and it seems to me that when I was in the cradle, a kite came to me and opened my mouth with its tail and pushed its tail between my lips many times."

The first psychoanalytical study of Leonardo's childhood memory was carried out 400 years later by Sigmund Freud himself, who said that it was not his purpose to "defile a genius," but that no-one was "so great that it would be a shame for him to submit to the laws governing normal and abnormal behaviour with equal rigour." Freud interpreted the autobiographical note as a dream with unconsciously coded memories and meanings. He links it with Leonardo's overdeveloped and unresolved link with his mother, who (he claimed) brought him up in the fatherless first years with exaggerated attention and affection. The father thus represented a potential threat to the relationship with the mother, symbolized by the thrashing tail of the bird. Freud derived from Leonardo's life the concept of an "ideational homosexual" type, which Leonardo embodied without having necessarily actively practised his unconventional sexuality. Freud's analysis of Leonardo's work also highlights supposed narcissistic and homoerotic tendencies in the artist.

Figure studies for the
Adoration of the Magi
(p. 52).

As a basis for his analysis, first published in 1910, Freud used an early German translation of the manuscript containing a translation error of some importance for his interpretation. His theory is based on symbolic associations with vultures instead of kites. Freud's champions nonetheless defend the Freudian hypothesis: the kite could represent a hostile, envious mother — from a psychoanalytical point of view, an aspect resembling exaggerated maternal attention in tending to produce homosexual behaviour. Likewise the scant biographical data Freud started from has since been modified, though the uncertain relationship with the mother remains.

Freud's theory is no longer given any credence, particularly after criticism from art historian Meyer Schapiro during the 1950s. Schapiro accused Freud of highly speculative psychology and of projecting his own life on Leonardo.

However dubious Freud's theories may have been, the psychoanalytical evaluation of Leonardo's note still deserves attention; certainly the idea that Leonardo's recollection might be connected with feelings for his mother remains intriguing.

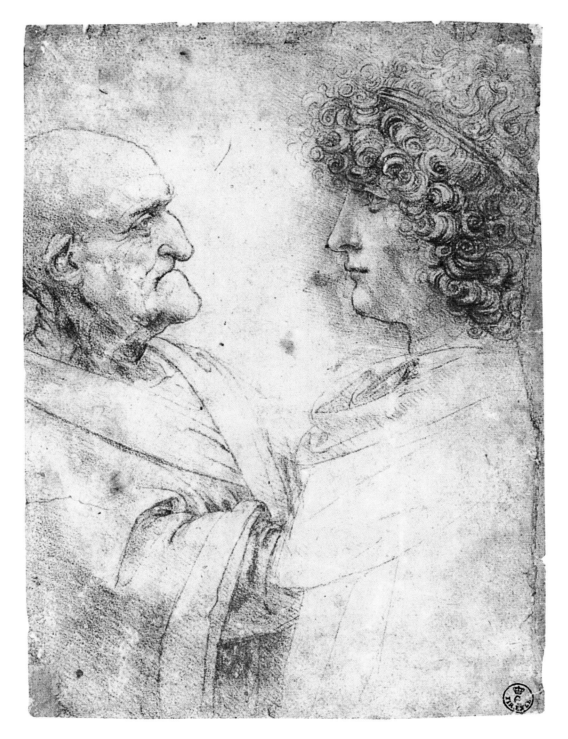

Double portrait Leonardo's drawings include this *Profile studies of an old man and a young man (Salai?) facing each other*. Some writers see this as a self-portrait of the artist, who recognized that he constitutes a father figure to the desired youth rather than a lover.

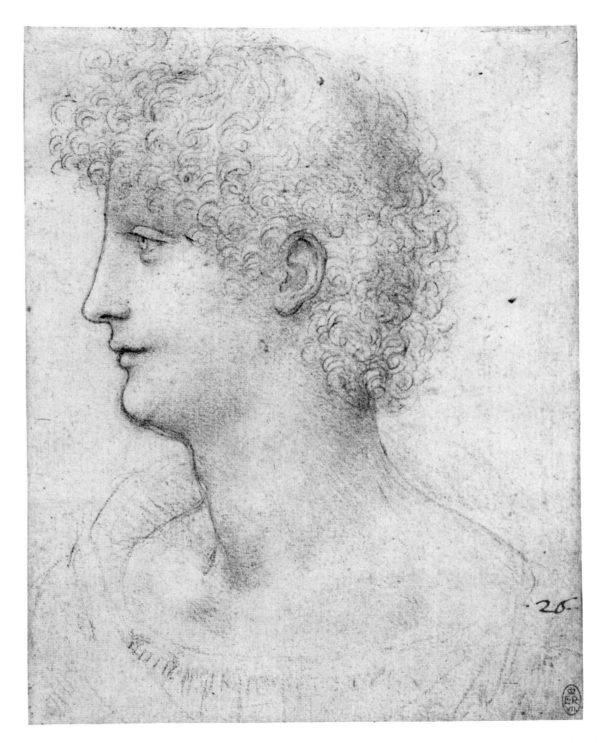

"Little Devil" Various drawings by Leonardo have been seen as depictions of Salai, the "graceful and well-formed youth with curly hair, in which Leonardo took peculiar pleasure," according to Vasari.

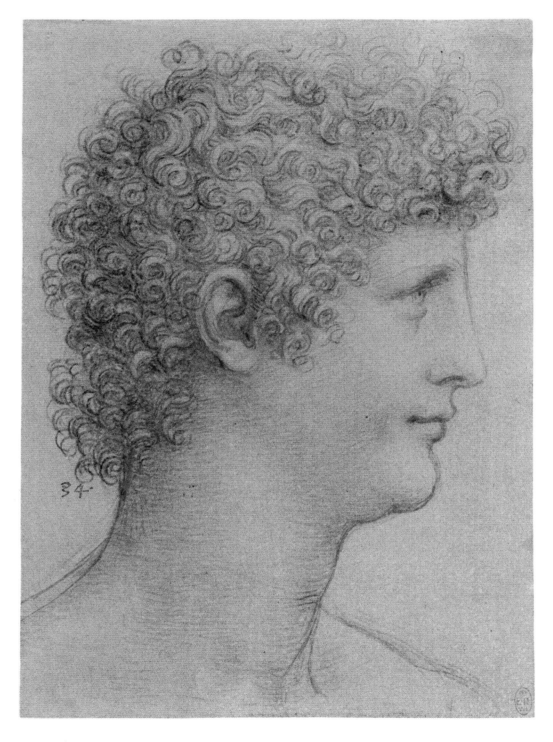

Profile study of a young man This drawing is also seen as a portrait of Salai, who entered Leonardo's workshop as a 10-year-old and remained with the artist for a quarter of a century.

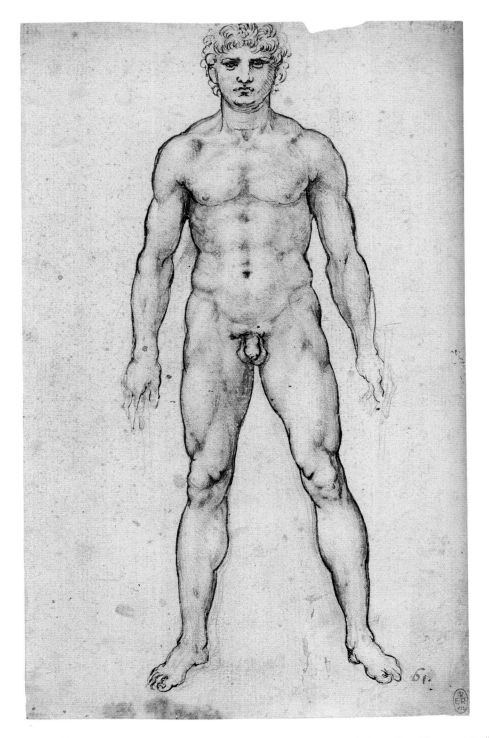

Man as the focus of interest This nude study is closely connected with the artist's developing self-confidence and the "discovery" of man and his anatomical constitution. Leonardo's drawings of nude male bodies are also interpreted as an indication of his homosexuality.

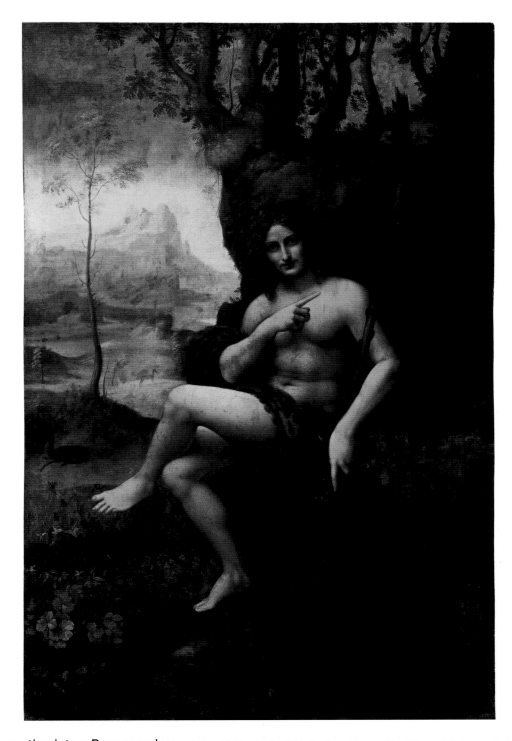

Transformation into a Roman god This painting, *St John the Baptist in the Desert*, is possibly a late work by Leonardo, though there is no clear documentary evidence of it. It is also described as *St John the Baptist with the Attributes of Bacchus*, though that relates to overpaintings in the late 17th century (ivy garland, the skin a wild animal and a long cross transformed into a classical thyrsus).

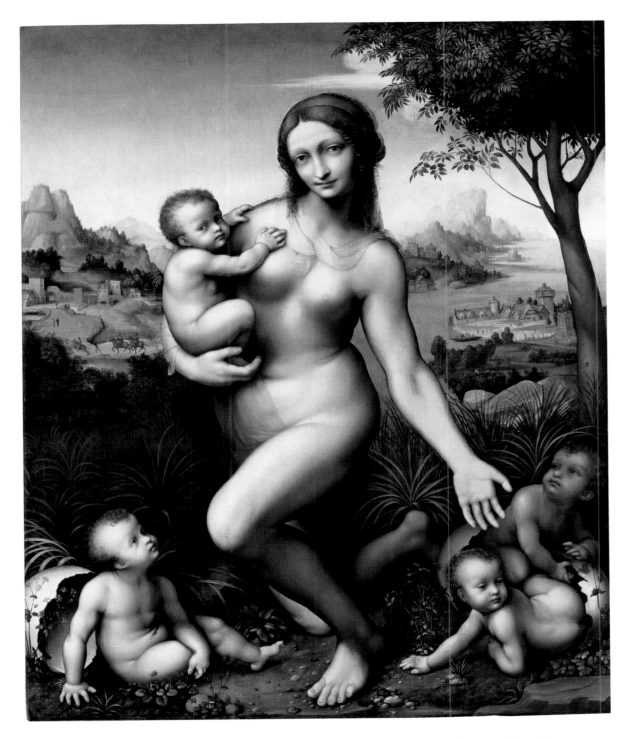

Leda and her Children Leonardo executed at least two variants of the Leda theme (compare p. 91). A copy by Giampetrino among Leonardo's immediate associates records the "kneeling Leda" variant known only from preliminary drawings. In it, she is shown with her children Castor and Pollux, Helen and Clytemnestra — but Zeus, the father, who had taken on the form of a swan, is missing.

Today

"It's been a pleasure to work with him, with his *Last Supper*, but no artist these days can be compared with this genius."

Andy Warhol on Leonardo da Vinci, 1987

The Appeal of Leonardo ...

... remains undiminished. His works of art satisfy a need for beauty and depth, while his scientific studies seem entirely modern, perhaps because they are superbly illustrated and so have an especial appeal in a visual age. And his writings contained so much diverse knowledge that they could be described as an early hypertext.

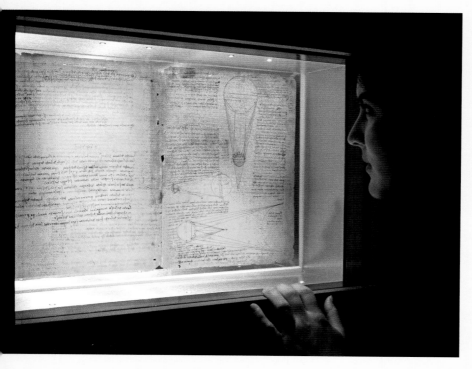

$30.8m ...

... was the amount paid at auction in 1994 by Bill Gates for the Codex Leicester, named after Thomas Coke, created Earl of Leicester in 1744, who bought the codex on his travels in 1717. The 18-page scientific work thus became the most expensive book in the world. Once a year, it is put on public display in a different city around the world.

Exhibition venues featuring major works by Leonardo da Vinci:

- → Cracow, Museum Czartoryski: *Lady with the Ermine*
- → Florence, Uffizi (right): *Adoration of the Magi, Annunciation*
- → London, National Gallery: *Virgin of the Rocks* (2nd version), *Burlington House Cartoon*
- → Milan, Castello Sforzesco: Salla delle Asse
- → Milan, Santa Maria della Grazie: *Last Supper*
- → Munich, Pinakothek: *Madonna with the Carnation*
- → Paris, Louvre (below): *Mona Lisa, Virgin of the Rocks* (1st version), *Virgin and Child with St Anne, La Belle Ferronière, St John the Baptist, Bacchus*
- → Rome, Vatican Museums: *St Jerome*
- → St Petersburg, Hermitage: *Benois Madonna*
- → Washington, National Gallery: *Ginevra de' Benci*

Currently the most expensive drawing in the world ...

... is one of Leonardo's early postcard-size horse studies for the *Adoration of the Magi*. It was sold at Christie's in London in 2001 for $12m.

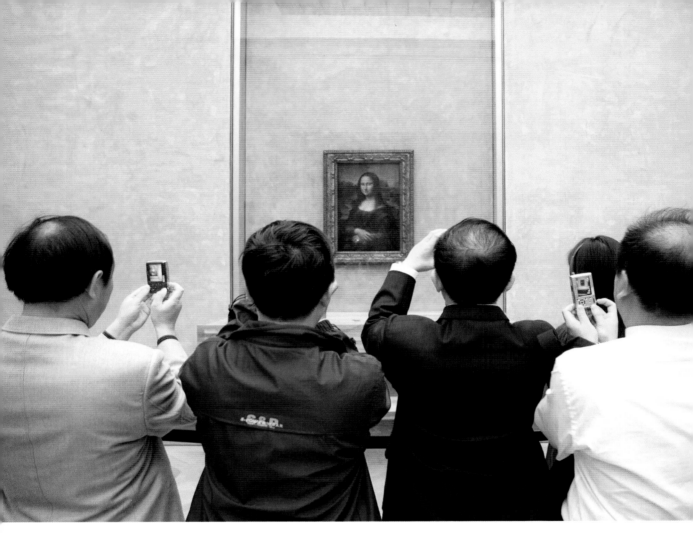

Visitors to the Louvre photographing the *Mona Lisa*.

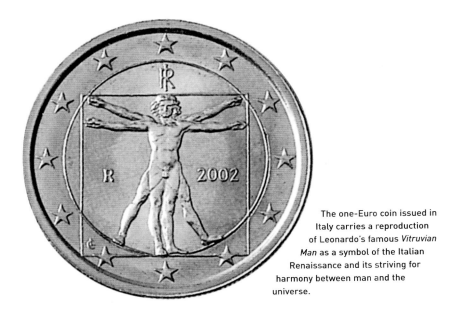

The one-Euro coin issued in Italy carries a reproduction of Leonardo's famous *Vitruvian Man* as a symbol of the Italian Renaissance and its striving for harmony between man and the universe.

Tributes to Leonardo da Vinci

Leonardo da Vinci is one of the most famous personalities in European history, and his importance in the history of art is uncontested. There are countless publications, researcher programmes and exhibitions attempting to plumb the depths of his character and his work, to exploit or glorify them, or even to cast doubt on their importance.

Various places now capitalize on his associations with them. The importance of the cities of Florence and Milan is obvious, given his career. The latter has a special Leonardo research centre (the Raccolta Vinciana) to promote studies of his work. Arezzo has also made much use of the artist's name and put on a whole series of exhibitions. Many of the landscapes in his paintings, it is claimed, were inspired by places in the immediate vicinity of the city.

The town of Vinci has focused on the intellectual and scientific side of the life and work of its native son. A modest stone house in Anchiano, two miles from the town centre, is

A replica of a bicycle made on the basis of Leonardo's drawings, in the Museo Leonardiano in Vinci.

presented as the house where he was born, and has become a major tourist attraction. A cultural trail round the town tracing places associated with its one-time resident takes in (among other things) the church of Santa Croce, where a font can be seen, said to be that of Leonardo's baptism. Visitors wanting more information about the famous man can visit the Museo Leonardiano in the former *castello* of the Counts of Guidi, inaugurated in 1952, though further exhibition space was later added in the Palazzina Uzielli. Its extensive collection of machines made from Leonardo's drawings presents him as a technician, engineer and scientist. The exhibits include machines for making textiles, building machines and military contraptions, plus devices for moving on the water, in and on the ground, and a self-propelled cart (or "auto-mobile"). The near-

by library specializes in documenting Leonardo's works. Since its opening in 1928, it has been a meeting place for students and researchers looking for facsimile reproductions of all well-known drawings and manuscripts plus written works by him printed since the beginning of the 16th century. On prior notification, visitors can also consult more than 7,000 monographs in various languages there. Since 1960, the library has also hosted the scholarly conference Lettura Vinciana, which takes place every year as part of the "Leonardo Celebrations."

France also makes much of its Leonardo connections, on the grounds that this was his last home and where

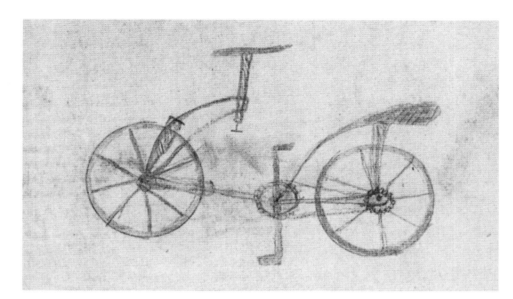

Leonardo's famous drawing of a bicycle in the Codex Atlanticus.

his true genius was recognized. The Louvre has made a special effort to build up an important collection of his works of art, and notably has the *Mona Lisa* among its treasures. The portrait attracts millions of visitors to the museum every year. Those with little time simply follow the signs showing the shortest way to the painting.

At Amboise is the Château Clos Lucé (previously Château de Cloux), which Francis I made available to Leonardo as a place to live and work. This is where he spent his last years until he died. The house and its small park are downhill from the well-known Château Amboise, to which it is connected by a subterranean passage. It now contains a small museum exhibiting a series of models of his designs and inventions, a number of sketches, and copies of several paintings. The Chapel of St Florentin, where Leonardo was interred, no longer exists. His supposed mortal remains are now in the Gothic chapel of St Hubertus in Amboise.

Twentieth-century responses

Leonardo's immense output still engrosses scholars of various disciplines in art and science, who have to do meticulous detective work on the gigantic puzzle that his manuscripts constitute. New general works are frequently published and specialized aspects studied, down to the use of the word "*etc.*" in his notebooks. As recently as 1964, a sensational find of two original manuscripts in the National Library in Madrid triggered off a renewed wave of publications.

Leonardo has become part of our everyday culture. His famous drawing of human proportions based on Vitruvius graces the reverse of the Italian one-Euro coin, and serves as an emblem for physicians' associations and humanist societies. The main airport in Rome is named

Andy Warhol's *Thirty are Better than One.*

after him, as are an EU educational programme, a successful German consumer label for glassware and gifts, a project for space flight, a data-transmission program ... and many more.

There seems likewise no end to the popularity of the *Mona Lisa.* After it was stolen from the Louvre just before World War I, the 20th-century art avant-garde challenged the myth of the painting and made it an object of parody. In 1919, Marcel Duchamp gave Lisa a moustache and goatee beard, and called his ready-made *L.H.O.O.Q* (when pronounced in French, these initials sound like *elle a chaud au cul,* "she has a hot ass"). Fifty years later, he revisited this "work," removing the beard and calling it *L.H.O.O.Q. Rasée* ("shaved"). Many artists have had their say, including Robert Rauschenberg, René Magritte and Andy Warhol — the last-named

made a silkscreen reproduction called *Thirty are Better than One.* In the early 1990s, French performance artiste Orlan caused astonishment when, in front of video cameras, she had cosmetic surgeons perform procedures to make her resemble the *Mona Lisa.*

Many other artists and cartoonists have likewise made much of Leonardo's famous portrait. It has featured in songs (Nat King Cole's *Mona Lisa* and Bob Dylan's *Visions of Johanna*), comics and cyberpunk novels (William Gibson's *Mona Lisa Overdrive*). Posters of it hang on the walls of today's homes (just as Leonardo's original painting once hung on the wall of Napoleon's bedroom), occasionally with a joint in the mouth. Marketing today manifests little respect, as is evident in the constant output of new versions on postcards, souvenirs, ties, T-shirts, cups and mouse pads.

The poster for the film
of *The Da Vinci Code*,
with Audrey Tautou
and Tom Hanks.

Reality or fiction?

Why Mona Lisa Smiles is the title of a book by Paul Barolsky. It raises one of many unanswered questions to do with Leonardo's paintings. Such enigmas inspire a steady flow of interest in a personality who is difficult to fathom and whose works demand their constant rediscovery. In 2003, Dan Brown published his famous *The Da Vinci Code*, a phenomenal bestseller linking Leonardo with secret societies and conspiracy theories. The book had sold more than 50 million copies before the eponymous film hit the screens in 2006, with Tom Hanks and Audrey Tautou in the starring roles.

According to Dan Brown, the book is based on historical fact, and he promises no less than the liberation of humanity by solving the "mysteries of the greatest art works." The author asserts that there was a marriage between Jesus and Mary Magdalene that produced a son; and that Leonardo da Vinci knew this and left coded messages alluding to it in his paintings. It was a wildly successful hypothesis, triggering off sharp reactions from the Roman Catholic Church and other religious bodies. After the book appeared, the conference of American bishops launched a large-scale campaign with a home page (www.jesusdecoded.com) that was intended to provide reliable information on Christ and the life of Jesus. Numerous publications followed, including some by art historians, dealing with the truth or otherwise of the book and refuting the "facts" with history.

Dan Brown will not be the last to reinvent Leonardo. One can only agree with the celebrated English art historian Kenneth Clark — our image of Leonardo's is that of a cloud that constantly changes shape.

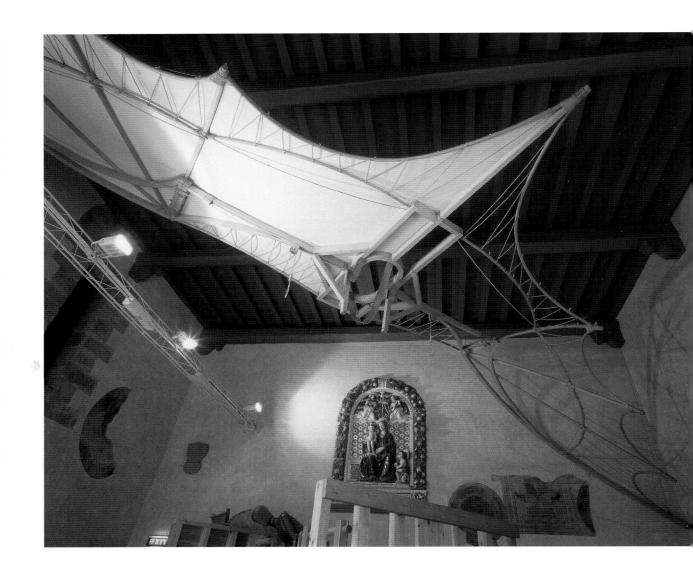

Museo Leonardiano Leonardo's drawings contain detailed designs of flying machines based on bird flight. The museum in Vinci has constructed an "ornithopter" on the basis of a Leonardo sketch.

His last home Château Clos Lucé (previously Château de Cloux) was where Leonardo lived from 1516 until his death. There were extensions in the 18th century, but the central part dating from the 15th century has presumably remained unchanged since Leonardo's day.

Dada Marcel Duchamp's *L.H.O.O.Q.* is a postcard with a reproduction of the *Mona Lisa*, to which he added a moustache and goatee beard. At the time, that amounted to a frontal attack on traditional art.

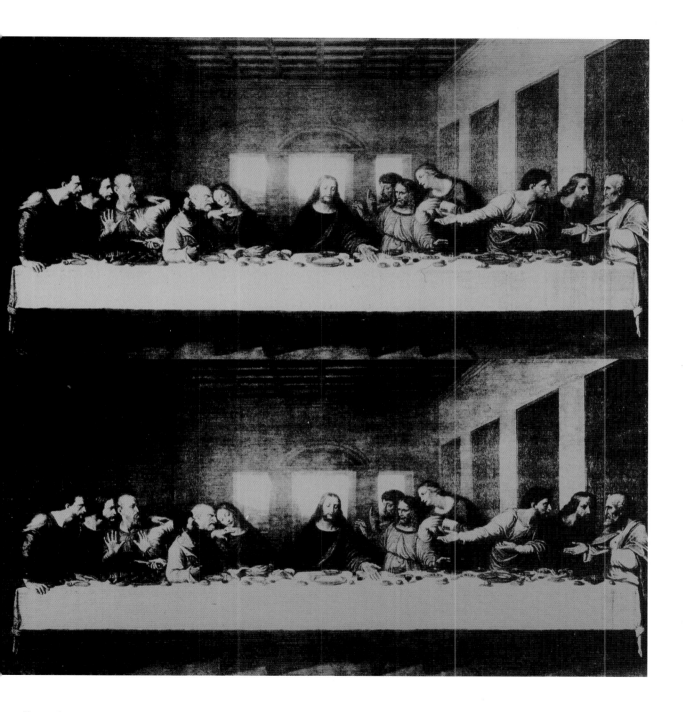

Paraphrase Andy Warhol's series of *Last Supper* paintings consists of more than 100 pictures. A kitsch relief of Leonardo's *Last Supper*, which he transformed by painting over it and then photocopying it, forms the starting point of his work.

Picture list:

Page 1: Leonardo da Vinci, *Lady with the Ermine (Portrait of Cecilia Gallerani)*, detail, 1489/1490, see p. 88

Page 5: Raphael, *School of Athens*, detail, 1510, see pp. 14–15

Page 6: Cover of Giorgio Vasari's *Lives of the Painters*, with a portrait of Leonardo

Page 7 top: Raphael, *Pope Julius II*, 1511/12, 108 x 80 cm, oil on wood, Uffizi, Florence

Page 7 bottom: Agnolo Bronzino (workshop), *Portrait of Lorenzo de' Medici*, c. 1553–1568, oil on tin, 15 x 12 cm, Museo Mediceo, Palazzo Medici-Riccardi, Florence

Page 8: Florence's cathedral, Santa Maria del Fiore

Page 9: Giuliano Bugiardini, *Portrait of Michelangelo Buonarroti in a Turban*, c. 1522, oil on canvas, 55.3 x 43.5 cm, Casa Buonarroti, Florence

Page 10: Pisanello and Matteo de' Pasti, *Bronze medallion with a portrait of Leon Battista Alberti*

Page 11: Interior of the Sistine Chapel, Vatican, Rome

Page 12: Masaccio, *Trinity*, c. 1427, fresco, 667 x 317 cm, Santa Maria Novella, Florence

Page 13: Fra Angelico, *Visitation*, predella from the *Annunciation* altarpiece, c. 1440, tempera on wood, 20 x 28 cm, Museo Diocesano, Cortona

Pages 14–15: Raphael, *School of Athens*, 1510, fresco, base length approx. 770 cm, Stanza della Segnatura, Vatican, Rome

Page 16: Jan van Eyck, *Double Portrait of Giovanni Arnolfini and his Bride Giovanna Cenami (Arnolfini Wedding)*, 1434, oil on wood, 81.8 x 59.7 cm, National Gallery, London

Page 17: Albrecht Dürer, *Self-Portrait in a Fur Coat*, 1500, oil on wood, 67 x 49 cm, Alte Pinakothek, Munich

Page 19: Leonardo da Vinci, *Vitruvian Man*, c. 1490, see p. 72

Page 20: J.H.W. Tischbein, *Goethe in the Roman Campagna*, 1786, Städel Museum, Frankfurt

Page 21 top: Leonardo da Vinci, *Turin Self-Portrait*, c. 1512, sanguine drawing, 33.2 x 21.2 cm, Biblioteca Reale, Turin

Page 21 bottom: Leonardo da Vinci, anatomical study of the layers of the brain and scalp, c. 1490–1493, pen, brown Indian ink and red crayon, 20.3 x 15.2, Royal Library (RL 12603r), Windsor Castle

Page 22: Leonardo da Vinci, *Virgin and Child with St Anne*, c. 1502–1513, oil on poplar wood, 168.5 x 130 cm, Louvre, Paris

Page 23: Raphael, *Self-Portrait*, c. 1509, oil on wood, 45 x 35 cm, Uffizi, Florence

Page 24: Jacobo de' Barbari, *Luca Pacioli, Divina Proportione*, 1495, oil on wood, 98 x 108 cm, Museo Nazionale di Capodimonte, Naples

Page 25: Leonardo da Vinci, *Study of the proportions of a horse*, c. 1489, silverpoint drawing, 32.4 x 23.7 cm, Royal Library (RL 12319r), Windsor Castle

Page 26: Jean Clouet, *Francis I*, c. 1525, 96 x 74 cm, Louvre, Paris

Page 27 top: Peter Paul Rubens, *The Battle of Anghiari*, 1600–1608, black crayon, charcoal and Indian ink, 45.2 x 63.7, Louvre, Paris

Page 27 bottom: Aristotile (or Bastiano) da Sangallo, *The Battle of Cascina*, c. 1542, grisaille on canvas, 76.5 x 130 cm, Holkham Hall, Norfolk, Earl of Leicester Collection

Page 28: Andrea del Verrocchio and his workshop, *Baptism of Christ*, c. 1470–1472 and 1475, oil and tempera on poplar wood, 180 x 151.3, Uffizi, Florence

Page 29: Leonardo da Vinci, *Madonna with the Carnation*, c. 1472–1478, tempera and oil (?) on poplar wood, 62.3 x 48.5 cm, Alte Pinakothek, Munich

Pages 30–31: Verrocchio's workshop, *Annunciation*, c. 1473–1475 (?), oil and tempera on poplar wood, 100 x 221.5 cm, Uffizi, Florence

Page 32: Leonardo da Vinci, *Anatomical study of the stomach and gut*, c. 1506, pen and brown Indian ink on traces of black crayon, 19.2 x 13.8 cm, Royal Library (RL 19031v), Windsor Castle

Page 33: Printed edition of Leonardo's treatise on painting (*Trattato della Pittura*), with illustrations by Nicholas Poussin, 1651

Page 34: Photograph of Vincenzo Perugia, who stole the *Mona Lisa*

Page 35 top: Postcard celebrating the return of the *Mona Lisa* to the Louvre

Page 35 bottom: Guards in front of the *Mona Lisa* during the exhibition in Washington, DC

Page 36: Leonardo da Vinci, *Mona Lisa (La Gioconda)*, 1503–1506 and later (1510?), oil on poplar wood, 77 x 53 cm, Louvre, Paris

Page 37: Leonardo da Vinci, *Mona Lisa*, detail

Pages 38–39: Leonardo da Vinci, *Last Supper*, c. 1494–1498, mixed technique, 460 x 880 cm, Santa Maria delle Grazie, Milan

Page 41: Andrea del Verrocchio and his workshop, *Baptism of Christ*, detail, c. 1470–1472 and 1475, see p. 28

Page 42: Giovanni Antonio Boltraffio (?) and Leonardo da Vinci, *Litta Madonna*, c. 1490, tempera (and oil?) on wood, 42 x 33 cm, Hermitage, St Petersburg

Page 43 top: Unknown artist, copy of Leonardo's *Last Supper*, 16th century, oil on canvas, 418 x 794 cm, Da Vinci Museum, Tongerlo

Page 43 bottom: Andrea del Verrocchio and Leonardo da Vinci (?), *Tobias and the Angel*, c. 1470–1472, tempera on poplar, 84.4 cm x 66.2 cm, National Gallery, London

Page 44: Leonardo da Vinci, *Portrait of Ginevra de' Benci*, c. 1478–1480, oil and tempera on poplar wood, 38.8 x 36.7 cm, National Gallery of Art, Washington, DC, Ailsa Mellon Bruce Fund

Page 45: Leonardo da Vinci (?), *Male head with profile and details of proportions*, c. 1490, pen and ink drawing, 28 x 22 cm, Galleria della'Accademia, Venice

Page 46: Leonardo da Vinci, *Study of drapery for a kneeling figure in profile*, c. 1472–1475 (?), tempera with white highlights on canvas with grey ground, 20.6 x 28.1 cm, Louvre, Paris

Page 47: Andrea del Verrocchio and his workshop, *Baptism of Christ*, detail, c. 1470–1472 and 1475, see p. 28

Page 48: Leonardo da Vinci, *Madonna with the Carnation*, detail, c. 1472–1478, see p. 29

Page 49: Leonardo da Vinci, compositional sketch for the *Adoration of the Magi (Gallichon Drawing)*, 1481, pen and ink over metal point, 28.5 x 21.5 cm, Louvre, Paris

Page 50: Leonardo da Vinci, *Study of a hand*, c. 1483, black crayon, white highlights, 15.3 x 22 cm, Royal Library (RL 12520r), Windsor Castle

Appendix

Page 51: Leonardo da Vinci (?), *Portrait of Ginevra de' Benci*, reverse, c. 1478–1480, tempera (and oil?) on poplar wood, 38.8 x 36.7 cm, National Gallery of Art, Washington DC, Ailsa Mellon Bruce Fund

Page 52: Leonardo da Vinci, *Adoration of the Magi*, 1481–1482, oil on wood, 243 x 246 cm, Uffizi, Florence

Page 53: Leonardo da Vinci, *St Jerome*, c. 1480–1482, oil and tempera on walnut, 102.8 x 73.5 cm, Pinacoteca Vaticana, Rome

Page 54: Gian Giacomo Caprotti (?) from a design by Leonardo da Vinci, *Madonna with the Yarnwinder*, c. 1501–1507 (?), oil on wood, 50.2 x 36.4 cm, privately owned, New York

Page 55: Giovanni Antonio Boltraffio (?) and Leonardo da Vinci (?), *Portrait of a Musician*, c. 1485, oil and tempera on walnut (?) wood, 44.7 x 32 cm, Pinacoteca Ambrosiana, Milan

Page 56: Unknown artist (Bologna?), *Madonna and Child*, undated, tempera (?) on wood, Milan, private collection

Page 57: Leonardo da Vinci, *Mona Lisa*, detail, see p. 36

Page 58: Leonardo da Vinci, *Study for the Sforza monument*, c. 1488–1489, silverpoint, 14.8 x 18.5 cm, Royal Library (RL 12358), Windsor Castle

Page 59: Leonardo da Vinci, *Study for the Sforza monument*, c. 1488–1489, metal point, Royal Library (RL 12357r), Windsor Castle

Page 60 left: Leonardo da Vinci, *Last Supper*, detail of James the Great, c. 1494–1498, see pp. 38–39

Page 60 right: Leonardo da Vinci, *Study for the Last Supper* (James the Great), c. 1495, sanguine, pen and ink, 25 x 17 cm, Royal Library (RL 12552r), Windsor Castle

Page 61: Leonardo da Vinci, *Study for Virgin's drapery* (sketch for the painting of *Virgin and Child with St Anne*), c. 1501, black chalk, black Indian ink, white highlights, 23 x 24.5 cm, Louvre, Paris

Page 62: Leonardo da Vinci, *Portrait of a Young Woman in Profile (Isabella d'Este)*, c. 1499/1500, black and red crayon, 63 x 46 cm, Louvre, Paris

Page 63: Leonardo da Vinci, *Casting mould for the head of the Sforza horse*, c. 1491–1493, red crayon, 21 x 29 cm, Biblioteca Nacional, Madrid

Page 64: Leonardo da Vinci, *Study for the Trivulzio monument*, c. 1508–1511, pen drawing, 28 x 19.8 cm, Royal Library (RL 12355r), Windsor Castle

Page 65: Leonardo da Vinci, *Studies of cats, a dragon and other beasts*, c. 1513–1515, pen, crayon and Indian ink drawing, 27 x 21 cm, Royal Library (RL 12363r), Windsor Castle

Page 66: Leonardo da Vinci, *Studies of foetuses in the uterus and the structure and size of the female genitalia*, c. 1510, pen drawing, 30.4 x 21.3, Royal Library (RL 19101r), Windsor Castle

Page 67: Francesco Melzi (after Leonardo da Vinci), *Grotesque portrait studies with a caricature of Dante* (bottom right), original drawing c. 1492, sanguine, 19.5 x 14.6 cm, Royal Library (RL 12493r), Windsor Castle

Page 69: Leonardo da Vinci, *Virgin and Child with St Anne*, c. 1502–1513, see p. 22

Page 70: Photo of Vinci

Page 71 top: Giorgio Vasari, *Self-Portrait*, c. 1567, Uffizi, Florence

Page 72: Leonardo da Vinci, *Vitruvian Man*, c. 1490, pen, ink and metal point on paper, 34.3 x 24.5 cm, Galleria dell'Accademia, Venice

Page 73: Photo of Leonardo's birthplace

Page 74: Andrea del Verrocchio, *David*, pre-1476, bronze, height 125 cm, Museo Nazionale del Bargello, Florence

Page 75: *Florentina*, detail, "della catena" view of Florence, c. 1472, Museo di Firenze Com'Era, Florence

Page 76: Castello Sforzesco, Milan

Page 77: Leonardo da Vinci, ceiling painting in the *Sala delle Asse*, c. 1496–1497, tempera on plaster, Castello Sforzesco, Milan

Page 78: Leonardo da Vinci, *Arno Landscape*, 5 August 1473, pen drawing, 19 x 28.5 cm, Uffizi, Florence

Page 79: Leonardo da Vinci, *Profile of a warrior with helmet and armour*, c. 1472, silverpoint, 28.5 x 20.7 cm, British Museum, London

Page 80: Andrea del Verrocchio and Leonardo da Vinci (workshop?), *Dreyfus Madonna (Madonna with the Pomegranate)*, c. 1470–1472 (?), tempera and oil (?) on oak, 15.7 x 12.8 cm, National Gallery of Art, Washington, DC

Page 81: Leonardo da Vinci, *Benois Madonna*, c. 1478–1480, oil on wood transferred to canvas, 49.5 x 31 cm, Hermitage, St Petersburg

Page 82: School of Leonardo, *Portrait of a Lady (Beatrice d'Este)*, c. 1485–1490, oil on wood, 51 x 34 cm, Biblioteca Ambrosiana, Milan

Page 83: Leonardo da Vinci, *Figure studies of dancers*, 1500, Galleria dell'Accademia, Venice

Page 84: Leonardo da Vinci, *Study for a central-plan building*, c. 1487–1490, pen drawing, 23 x 16.7 cm, Bibliothèque de l'Institut de France (MS B2173, f. 22rl)

Page 85: Leonardo da Vinci, *Study for protective shields for soldiers plus an exploding bomb*, c. 1485–1488, pen drawing, 20 x 27.3 cm, École Nationale Supérieure des Beaux-Arts, Paris

Page 86 left: Leonardo da Vinci, *Burlington House Cartoon (Virgin and Child with St Anne)*, c. 1503–1510, black crayon and white lead on paper, 141.5 x 104 cm, National Gallery, London

Page 86 right: Leonardo da Vinci, *Head of Leda*, c. 1503–1507, black crayon, pen and ink on paper, 17.7 x 14.7 cm, Royal Library (RL 12516), Windsor Castle

Page 87: Leonardo da Vinci, *Town plan of Imola*, c. 1502, graphite, crayon, pen and wash on paper, 44 x 60.2 cm, Museo Vinciano, Vinci

Page 88: Leonardo da Vinci, *Lady with the Ermine (Portrait of Cecilia Gallerani)*, 1489/1490, 55 x 40.5, oil on walnut, Muzeum Narodowe, Cracow

Page 89: Leonardo da Vinci, *Virgin of the Rocks*, c. 1495–1499 and 1506–1508, oil on poplar wood (inlaid), 189.5 x 120 cm, National Gallery, London

Page 90: Leonardo da Vinci, *Portrait of an Unknown Lady (La Belle Ferronière)*, c. 1490–1495, oil on walnut, 63 x 45 cm, Louvre, Paris

Page 91: School of Leonardo, *Leda and the Swan*, c. 1508–1515, oil on wood, 130 x 77.5 cm, Uffizi, Florence

Page 92: Leonardo da Vinci, *The instruments for breathing, swallowing and speaking (uvula, pharynx, tongue and windpipe, larynx and oesophagus)*, c. 1509–1510, pen and brown Indian ink, 29 x 19.6 cm, Royal Library (RL 19002r), Windsor Castle

If you want to know more ...

Leonardo da Vinci has generated more interest among writers and academics than virtually any other artist. The literature about him is correspondingly vast. Below is only a small selection of more recent publications that are a good introduction to the life and work of Leonardo.

Contemporaneous sources:
Leonardo's notes have appeared in several translations, including: *The Notebooks of Leonardo da Vinci*, edited by Paul Richter (Dover, 1970); *The Notebooks of Leonardo da Vinci*, edited by Irma A. Richter (Oxford University Press, 1998). His *Treatise on Paintings* also appears in several versions, e.g. translated by J. F. Rigaud (Kessinger, 2004).

Giorgio Vasari's biography of Leonardo can be found in his *Lives of the Painters*, which is available online and in various editions and translations (e.g. Oxford University Press, 1998).

Studies and biographies:
A feast for the eye as well as containing the latest scholarly discoveries is **Frank Zöllner** and **Johannes Nathan**'s voluminous and lavish *Leonardo da Vinci*, which contains all the paintings and drawings (Taschen, 2003).

Pietro C. Marani's *Leonardo de Vinci* (Abrams, 2000) provides commentaries on all Leonardo's paintings.

Martin Kemp, Professor of Art History in Oxford, published a new work on Leonardo in 2004 (Oxford University Press), *Leonardo da Vinci: The Marvellous Works of Nature and Man*, in which the masterpieces are subjected to a new scrutiny. An older but still valuable introduction is **Kenneth Clark**'s *Leonardo da Vinci*, first published 1939, but revised by Kemp in 1993 (Penguin). **Charles Nicholl**'s biography, *Leonardo da Vinci: The Flights of the Mind* (Allen Lane, 2004) brings together modern research in a readable style. Another sound biography is **Serge Bramly**'s *Leonardo: The Artist and the Man* (Penguin Books, 1995).

Donald Sassoon's *Mona Lisa* (HarperCollins, 2002) provides a detailed guide to the *Mona Lisa* in terms of its original social and historical contexts, and also in terms of its subsequent history.

For those interested in his science:
Among the more accessible guides to Leonardo's achievements as a scientist are: **Michael White**, *Leonardo: The First Scientist* (St Martin's Griffin, 2001); **Claire Farago**, *Leonardo's Science and Technology* (Garland Publishing, 1999), which provides a guide for the general reader; and, looking at his work on anatomy, **Charles O'Malley**, *Leonardo da Vinci on the Human Body* (Gramercy, 2003).

Imprint

The pictures were kindly made available to us by the institutions and
people mentioned in the Picture List above, or are taken from the
publisher's archive, with the exception of:
akg-images, pages 24, 37, 71 top, 76, 83, 89, 113 top, 116, 119, 120, 121, 122
Arthothek, Weilheim: pages 17, 20, 29
Associated Press: pages 111, 112
National Gallery, London: pages 16, 86 left
Look: page 8
Ullstein: page 114

Library of Congress Control Number is available; British Library Catalo-
guing-in-Publication Data: a catalogue record is available from the
British Library;
The Deutsche Bibliothek has registered this publication in the German
National Bibliography. Detailed bibliographical data can be found online at:
http://dnb.d-nb.de

Prestel, a member of Verlagsgruppe Random House GmbH

Prestel Verlag
Königinstrasse 9
D-80539 Munich
Tel: +49 (89) 24 29 08-300
Fax: +49 (89) 24 29 08-335
www.prestel.de
info@prestel.de

Prestel Publishing Ltd.
4 Bloomsbury Place
London WC1A 2QA
Tel: +44 (0) 20 73 23-5004
Fax : +44 (0) 20 73 36-8004
www.prestel.com

Prestel Publishing
900 Broadway, Suite 603
New York, NY 10003
Tel: +1 (212) 995-2720
Fax: +1 (212) 995-2733

Editorial direction by Claudia Stäuble
Translated from the German by Paul Aston
Copy-edited by Chris Murray
Series editorial and design concept by Sybille Engels, engels zahm + partner
Layout by Wolfram Söll
Typesetting by EDV-Fotosatz Huber
Cover by Benjamin Wolbergs
Repro by ReproLine Mediateam
Printed and bound by Druckerei Uhl, Radolfzell

FSC
Mix
Produktgruppe aus vorbildlich
bewirtschafteten Wäldern und
anderen kontrollierten Herkünften
Zert.-Nr. GFA-COC-001526
www.fsc.org
© 1996 Forest Stewardship Council

Verlagsgruppe Random House FSC-DEU-0100
The FSC-certified paper *Gardamatt Art*
has been supplied by Cartiere del Garda S.p.A.

Printed in Germany

ISBN 978-3-7913-4336-5